CHARACTER

MENTOR

CHARACTER
MENTOR

CHARACTER MENTOR

Learn by Example to Use Expressions, Poses, and Staging to Bring Your Characters to Life

Tom Bancroft

Routledge
Taylor & Francis Group

LONDON AND NEW YORK

First published 2012 by Focal Press

Published 2019 by Routledge
52 Vanderbilt Avenue, New York, NY 10017
2 Park Square, Milton Park, Abingdon, Oxon OX14 4RN

Routledge is an imprint of the Taylor & Francis Group, an informa business

Library of Congress Cataloging-in-Publication Data
Bancroft,Tom.
 Character mentor : learn by example to use expressions, poses, and staging to bring your characters to life / Tom Bancroft.
 pages cm
 ISBN 978-0-240-82071-2 (pbk.)
 1. Characters and characteristics in art. 2. Graphic arts--Technique. I. Title.
 NC825.C43B355 2012
 743.4--dc23
 2012003222

British Library Cataloguing-in-Publication Data
A catalogue record for this book is available from the British Library.

ISBN 13: 978-0-240-82071-2 (pbk)

CONTENTS

INTRODUCTION

When I started contemplating this book, which I consider a companion book to my first book *Creating Characters with Personality*, I viewed the subject matter as, "Now that you have your character designed, what do you do with it?" The concepts that I felt were the next steps in applying to the world of character design were posing, expressions, and staging your characters. Those three subjects easily contained enough content for a book. That was it! I was off to writing my second book!

But how best to address those subjects?

I received positive responses about my *Creating Characters* book from up-and-coming artists who said they enjoyed the "assignments" that I ended each chapter with. It gave the artists the ability to apply, on their own, some of the lessons that were taught in that chapter. Additionally, I received many letters from art schools all over the country that have used those assignments as part of their character design class curriculum. That got me thinking about how we, as artists, learn.

Back in 1988, I attended the California Institute of the Arts (Cal Arts), one of the only schools (at the time) that taught traditional character animation. Walt Disney founded it, and many of our instructors were Disney animation artists or artists from other animation studios around the LA area. It was my first taste of having instructors who had practical experience and a master level of ability. The goal of this book is to continue that artistic tradition. Attending Cal Arts was a breath of fresh air but also a very humbling experience. I saw firsthand how a true master draftsman–level artist drew – and I felt like I had a long way to go.

Several of my instructors had also attended Cal Arts when they were younger. They told us stories of the wisdom and ability of their instructors and how they were passing that knowledge on to us. They described this way of learning as "mentoring." It is a way of learning that all craftsmen have used for hundreds of years. A master-level craftsman, someone who has 10 or 20 years of experience in their trade (such as woodworking, metalsmithing, sculpting, gourmet cooking, etc.) would mentor an apprentice or student to train them in the ways of that trade until they were able to make that trade their living and eventually become a master themselves. My first example of this was in my character design class at Cal Arts taught by the incredible Michael Giamo (who later went on to art-direct the film *Pocahontas* for Disney). Mr. Giamo had a very hands-on way of teaching. He would give out an assignment, show us examples by great artists of the past to illustrate his points, and then assign us to create our art to address the design challenge he presented. When we brought our assignments in the next class, he would review them in front of everyone, discussing the pros and cons of each piece. He always left time at the end of class to allow us to bring our drawings to him and receive one-on-one mentoring from him. For those who asked, he would lay a blank piece of paper over the student's drawing and do a quick sketch demonstrating how to improve the drawing. Watching Mr. Giamo draw was like watching magic happen: it was mesmerizing for us young, eager students. It was also, time and again, the moment I would learn a new concept or lesson. Watching a master, like Mr. Giamo, draw over my drawing, then flip back and forth between mine and his was like getting a year's worth of art education in a moment. I realize now that the reason I learned best that way was because it was visual. I had struggled with the same assignment and thought through it the best I could. Watching someone with Mr. Giamo's experience sit down and quickly sketch out a version I had not even considered was a valuable learning experience. Art instruction should always come down to visual illustration, not solely verbal instruction.

Mentorship as a way to learn was used by Disney animation also. In 1989, when I got my first job in animation at the (then) new Disney Feature Animation in Florida, the studio trained the young artists by having them work alongside experienced mentors. I was fortunate to have animation legend Mark Henn, animator of Ariel in *The Little Mermaid*, Young Simba in *The Lion King*, Jasmine in *Aladdin*, Tiana in *The Princess and the Frog*, and many others as my mentor for most of my career at Disney. We became good friends, but I never stopped honoring his instruction. Eric Larson – a Disney animation legend and one of Walt's Nine Old Men of animation – had trained Mark. I feel honored to have been trained in the lineage of such incredible artists. It is one of the reasons I write these books: to pass on that knowledge.

I want you, the reader, to approach this book with the mindset of an apprentice. I have more than twenty years of experience in my chosen artistic career and have applied that knowledge to feature film animation, TV animation, children's book illustration, comic book art, and video game development, and I am honored to share that experience with you. I have conceived this book so that each chapter progressively builds upon the previous one for you to apply what you have learned. Each chapter is like a separate class in art school. I have provided instruction on a given subject, followed with examples, and then assigned an artistic challenge. To visualize this for the book, I have asked artists in training to illustrate these assignments. They are, like you, apprentices. I have drawn over their drawings and made notes so that you can see different ways to improve upon the assignment from my perspective. In addition, I have asked artists from different areas of media, to create their version of assignment #6 (see page 141). You will see those examples throughout the book. I hope this book helps you on your journey to becoming a master. Enjoy the process!

Tom Bancroft

Franklin, Tennessee, August 2011

FOREWORD

I want you to put this book down. Right now.

I want you to put this book down, and instead watch some movies. Specifically, some movies that have bunches and bunches of stuff to do with mentors.

I'd say, "Go read a *book* that features bunches and bunches of stuff about mentors!" but that would be bad. I don't know what life is like on *your* coffee table, but on mine, the current book always gets piled on top of the last book, and the last book is promptly forgotten. Sure, it's safe from dust and your cat's pawprints, but it's forgotten. And I don't want you forgetting about *this* book. It's full of stuff I wish somebody had force-fed into *my* cabeza at an early stage.

But, I digress. *Movies*. Movies about mentors. (Bear with me, Tom; I'm goin' somewhere with this.)

Why? Because I want you to have, in your mind, the proper apprentice mindset when reading this book. All too many times, I've had young people (I love being old enough to use that term!) show me their portfolios, and they've looked at me like I was insane. My critique, my advice, my seasoned opinion – all fell on deaf ears. They didn't dig what I had to say. My guess is that they just wanted to have someone Farther Down the Path throw them some ego-gratifying kudos; they did *not* want the learned musings of a mentor.

But watch some movies about awesome mentorship. *Star Wars* (the first one), *The Karate Kid* (the first one), *The Matrix* (the first one, okay?). Anything cool like that. I want you to pay attention to the Apprentice, the Initiate, the Adept. I want you to see how this Student of the World goes through a character arc, a learning curve of growth. And I'm *not* talking about the Path to Mastery of the Force/Karate/Kung Fu. That's surface stuff.

I want you to pay attention to how the Pupil him- or herself changes; mainly, I want you to note his or her attitude.

Do you notice how the Apprentice always, *always* starts out by not believing 100 percent of the perceived crap falling out of the Learned Master's mouth? Without exception, the Apprentice always has a period during which, still intoxicated by the untrained natural talent that has driven them to the steps of the temple or the threshold of the hermit's cave, the Apprentice believes he or she knows *best*. It's an affectation of youth to believe anyone younger is an infant, and that anyone older is a senile geezer who needs their Depends changed. The Apprentice doesn't want to learn philosophy, or reason: they just want the mad skeelz. The *best* thing any apprentice learns is: any journey – real, artistic, spiritual – is about the actual steps, *not* the destination.

Think about journeying from New York to Los Angeles. On foot. If teleportation were possible, you'd probably prefer that to walking, no? Me, too, probably. But, if you could just be in Los Angeles at the press of a button, you'd pretty much be the exact same person, with the exact same perspective and decision-making skills, who left New York seconds ago in the Inter-Continental Re-Placeulator. But the *journey* of walking across an entire continent . . . that'd really change a person, don't you think? The people you'd meet along the way, the mistakes you'd make, and the inventive solutions you come up with to amend them – all those experiences would change you. They'd *improve* you. By the time you get to Los Angeles, you'd be a wiser individual, a more seasoned human being, a person who makes *much* more informed decisions than the kid that started out west on the Pulaski Skyway a couple months back. I mean, you can tell a person, "You should avoid bears!" but most people will probably think "Well, if push comes to shove, I could probably kill a bear with, I don't know, some sort of iPhone app." Only someone who's gone through the experience of running, screaming, from an enraged grizzly will actually know what the words "you should avoid bears" truly mean.

My point is that your decision-making process is altered by your years On Your Path. Even if there were some sort of magic that allowed you the skills of a master, you *still* wouldn't be able to do what a master does, because you wouldn't posses the master's years of experience. Half of being fabulous at something is having awesome decision-making skills, and that comes with time. Eric Clapton isn't a genius because of how fast or well he can play the guitar; he's a genius because of the notes his years of experience have helped him choose to play.

And that's what I'm getting at with the whole Mentor/Apprentice thing (like Halley's Comet, I always come around . . . eventually). Luke Skywalker initially doesn't want to go off with Ben Kenobi, even though he says he really wants to get off that dry saltine of a farm. He resists the Mentor's instruction at first, until he realizes that Ben knows best. The same with Mr. Miyagi and Morpheus. Daniel-san and Neo, regardless of their passion for what they want to learn from their respective masters, both of them have "this guy's full of crap" moments throughout the early stages of their studies.

But, if you're paying attention, you'll notice the moment when things start to turn around for our heroes. Without exception, it's the moment when they stop doubting. It's the moment they start *trusting the mentor*. The best thing *any* apprentice can do is put him- or herself *entirely* in the hands of their mentor. The Mentor knows best. He or she has already been there. *He or she knows more than you.* That's why you are there.

And that's why you're here, with this book, right now. You want to learn from someone who's been there, done that, and learned that you really, *really* don't stand a chance in a slap-fight with a bear. When you're reading this book, and Tom tells you something that makes you go "I don't know about that," always remember: *you're wrong.* When he tells you to practice drawing something that you think won't ultimately matter for the art *you* want to draw: *you're wrong.* The mentor knows best. The sooner you start trusting your particular mentor, the sooner you'll be on your way.

And when you're having those inevitable moments of mentor-doubt, which we *all* have at one point or another while studying under someone, remember Ben Kenobi, Mr. Miyagi, and Morpheus.

Ben Kenobi lies to Luke Skywalker, telling Luke a fabricated tale about his father's death. Is it because he's a bad mentor? Not at all. As Yoda says, two films later: "Not ready for the burden were you." Ben conceals the truth from Luke because Luke's not ready for a particular piece of information at that juncture in his journey. Your mentor might tell you something at a later point in your learning career that doesn't jibe with an earlier teaching. There's certain stuff you just can't process early on, so the mentor has to simplify things until you can handle the deeper stuff.

The Mentor knows best.

Mr. Miyagi makes Daniel-san wash his car, which Daniel-san thinks is a crap job. Wax on, wax off. Little does he know that Mr. Miyagi is having him do this to train his muscles for blocking and karate stuff! Don't question the training methods of your mentor; he or she knows better than you, remember? Do what you're told and remember to trust that you are in good mentor hands.

The Mentor knows best.

Morpheus tells Neo that everything that he knows is a lie, that the world is a dream created by a computer to turn people into batteries. Quite logically, Neo tells Morpheus that it's a load of brown stuff from the wrong end of the bull. I know I would; so would you. *But.* Morpheus is right, regardless of how insane he sounds to Neo. From time to time, your mentor will tell you something that makes absolutely no sense *whatsoever.* Your brain will be unable to parse that file, and you will attempt to write off your mentor as being stir-fry crazy. Doing this is

dumber than fighting that bear. Your mentor is more experienced than you, and has unlocked the secrets of the universe, the stuff of which you cannot e'en imagine in your philosophy. Well, maybe not *that* grand a sentiment, but a wise person listens to the words of someone even wiser than themselves. Trust what your mentor tells you, regardless of how much sense it makes now. Just tell yourself: "*Someday* I will understand what I was just taught; I just need to get to that day."

THE MENTOR KNOWS BEST.

Of course, none of this matters if you've gotten yourselves a bad mentor, some defective floor-model of a human being who will do you more harm than good. But you're in safe hands here. Tom knows his stuff, and if you trust in his mentorship, you'll leave this volume a bit wiser and farther down the path than when you started!

Adam Hughes

Atlanta, August 2011

ACKNOWLEDGMENTS

Thank you, readers, for buying this book – I hope it helps you in the pursuit of your artistic journey. I have enjoyed working on this book, but it would not have been worthwhile without the support of my wife, Jennifer, and our four girls, Lexie, Ansley, Emma, and Ellie. I love you all dearly. Thanks to my brother and sister, Tony Bancroft and Cami Avery, for their support and guidance throughout the two-year development of this book. *Huge* thankful thoughts go out to all the wonderful professional artists that contributed to this book, including: Adam Hughes (who wrote an incredible foreword, though I wish I had *also* asked for a drawing) and my good friend Megan Crisp; to the chapter "assignment" contributing artists: Bobby Rubio, Jeremiah Alcorn, Terry Dodson, Brian Ajhar, Sean "Cheeks" Galloway, Stephen Silver, and Marcus Hamilton; and to the mighty painter Chuck Vollmer and talented book designer Leonardo Olea for adding color and style to this book. Thank you also to my editor at Focal Press, Anais Wheeler, who got behind this book and supported it from the beginning. I appreciate your passion. To my second editor, David Bevans, who came in at the tough time of designing and editing the book and did a wonderful job. Also thanks to industry giants Matt Palmer and Cam Ford for their insights into my manuscript and helpful notes they gave me.

And last, but not least, thank you to the talented up-and-coming artists of deviantART who put out a huge effort to complete my mentor assignments so that I could review them and make my own chicken scratches over them! For every drawing that I printed here, about a dozen more from other talented artists were not used! You know who you are and I thank you. Thanks to the people who did make it in the book: Francisco Guerrero, Pasqualina Vitolo, Ole Christian Løken, Jaclyn Micek, Elaine Pascua, Lauren Draghetti, Andrew Chandler, and Usman Hayat.

If you are interested in learning more about drawing and designing characters or want to contact Tom Bancroft, please visit **www.charactermentorstudio.com** or go to his Facebook page at **Facebook.com /thebancroftbros**.

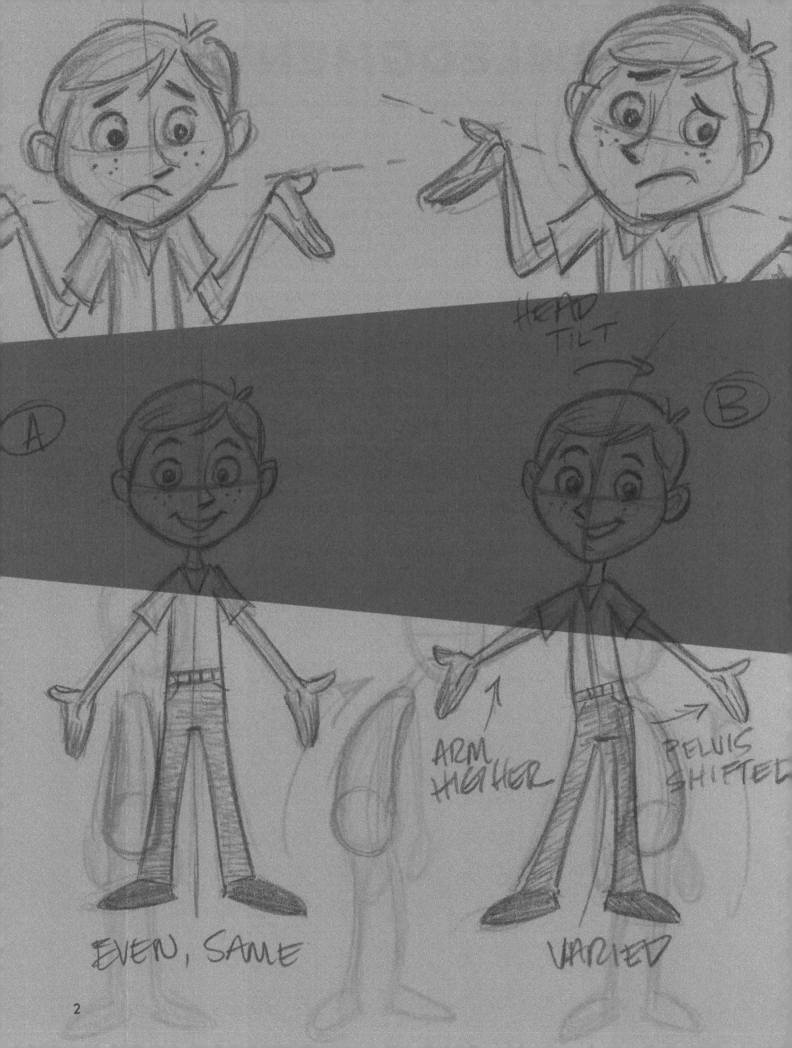

CHAPTER

NOW WHAT?
Drawing Basics for Posing and Expressions

1

NOW WHAT? 1

As I mentioned in the preface, this book starts with the conceit that you have a character or characters already designed—so now what do you do with them? You may want to use them in a comic book, a video game, an animated film, a TV show, or a children's book. How you use them is important, but what you are trying to communicate with them is what is *most* important. Drawing style does not matter concerning the instruction in this book. How you approach showcasing your characters is what matters.

If I had to write a "mission statement" for this book it would be this: *Character Mentor* is a book that communicates to artists of all styles and within all industries the importance of using posing, expressions, and staging to bring your characters to life. I believe that there is a "missing link" in our development as artists from our early beginnings of enjoying to draw to becoming a professional, working artist. My hope is that this book can be used as a tool to help bridge that gap.

Let's start with some general posing and expression basics and tips. These are some good ground rules and drawing pointers that we will be putting to use in later chapters. Unlike other sections of this book, these notes do not necessarily rely on a character's specific personality. They are lessons that can be applied to all characters.

TWINNING

If your character's arms, legs, or even the grin of its mouth is identical in position with its partner, we call this "twinning." Not that I have anything against twins (in fact, I am a twin, and I have twin girls), but "twinning" in your character's pose does not create a strong pose. Try to avoid this effect whenever possible. It makes for a dull, average pose and is generally considered a weak design. Offset your pose whenever possible.

A good example of twinning can be seen in the traditional "Ta-Da!" pose (see Figure A). Even in a flat, straight-on angle like this, a slight tilt to the head, bringing one of the arms up some, and placing the character's weight more on one leg than the other will break up the symmetry in the pose (Figure B). Same emotion in the pose, more interesting design.

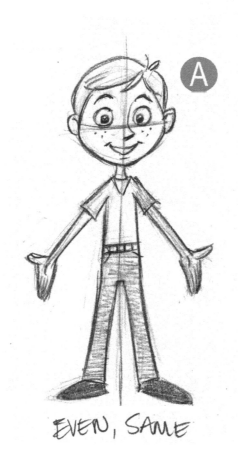

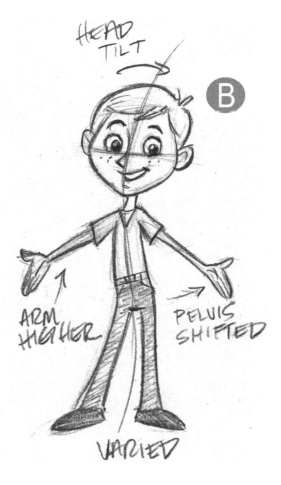

A subtler example of twinning is seen in an "I don't know" shrug pose. In this example, twinning is acceptable because it does communicate this very recognizable pose (Figure A). But, a slight tilt to the head and minor arm/hand adjustments can make the pose a bit more interesting while still communicating the idea (Figure B).

USING PERSPECTIVE TO CREATE DEPTH

A common practice of beginning artists is to leave perspective out of their characters' poses. It complicates the drawing, thus making it harder to create. Adding some depth to your pose will improve the pose immensely. Keep practicing your perspective in your character drawings and backgrounds; it will pay off! If your character is standing on the ground, rough in a ground plane that has some perspective to it rather than having a flat line for your character to stand on.

Adding some perspective/depth will:

- Help you avoid twinning in your character's stance. Even if your character has some symmetry to its pose, adding depth to its stance will automatically take away the twinning problem because of the differences in the sizes of the shapes. In Figure B, the foreground eye, ear, arm, and leg are bigger than the left side of the drawing which helps the drawing appear less symmetrical.

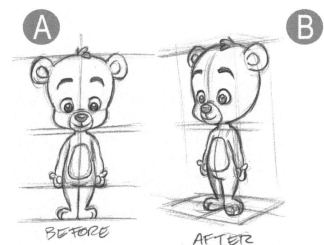

- Make your poses more dynamic. Note that the more dynamic angle in Figure B immediately gives more drama to the scene of the little girl reaching for the glass.

- Make poses more clear and give them a better silhouette. A good way to check your character's silhouette value is to shade it in on the back of your paper. Figure A, if shaded in would be very unclear what the boy was pointing at- or even that he was pointing at all! The pose in Figure B, clears that guesswork up!

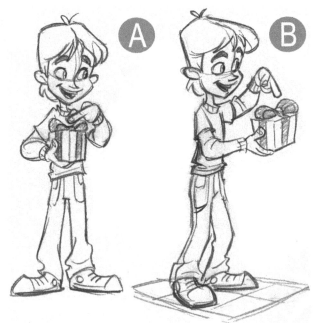

- Help strengthen expressions and emotions. The slump in the shoulders and the head hanging down can be seen clearer in the quarter-front view on the right than the dead-on front view on the left.

Remember that you have created your characters so they can be broken down into simple, basic shapes. This step will allow you to draw your character from different angles and perspectives. Think of the basic shapes of the head, eyes, lips, and nose of the face. Place them in the perspective within the circular shape of the head, remembering that shapes flatten as they turn away from the center (Figure A). This simplified drawing is the key to correctly replicating your characters from different angles. Once you have roughed out those basic shapes, you can then start adding details and refining the shapes of your character (Figure B).

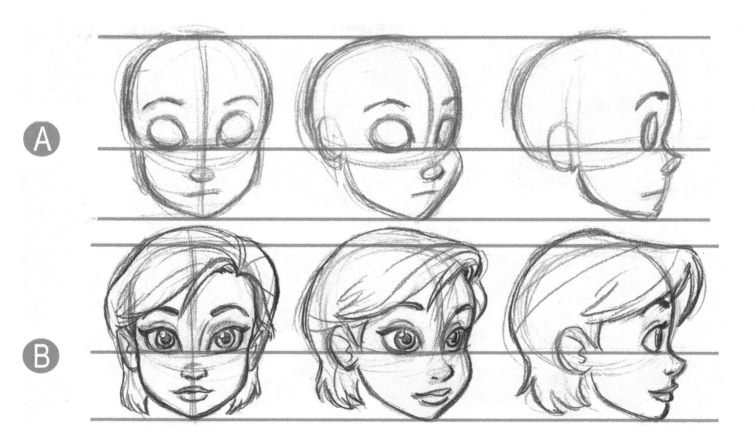

CLOTHING: DEPTH KILLERS?

We have all done it before: you have worked hard creating your character, putting him or her into a good pose, giving the character just the right expression, and then you quickly sketch in his or her clothing so that you can be done with your masterpiece. Be careful, as there are many ways you can hurt a good drawing by thoughtlessly throwing clothes on over it. Keep in mind that your character has depth and dimension. As you draw in the clothing on top of your character, consider how the cuffs will curve around the arms or legs – are they convex or concave circles? Are the wrinkles in the shirt or pants moving around the shape of the body or through it? The figure below shows the same pose drawn in two different ways: version A has perspective problems to the clothing; version B works with the perspective of the body. You've been warned: watch out for these depth killers!

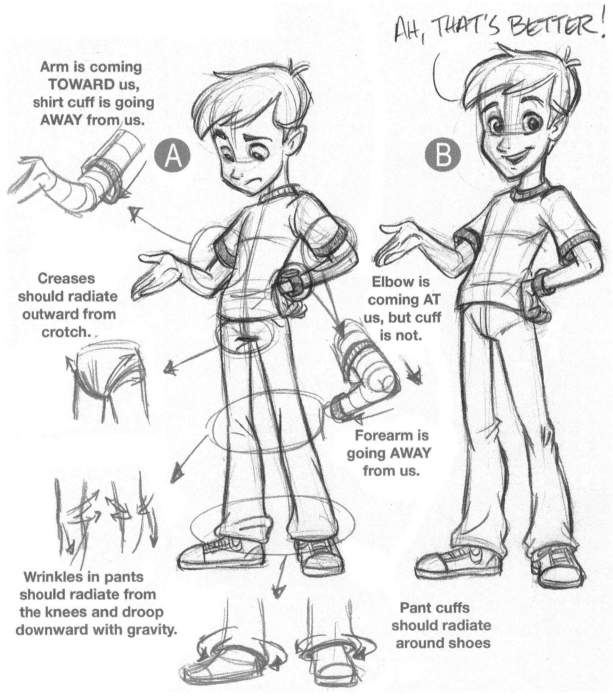

Arm is coming TOWARD us, shirt cuff is going AWAY from us.

Creases should radiate outward from crotch.

Wrinkles in pants should radiate from the knees and droop downward with gravity.

AH, THAT'S BETTER!

Elbow is coming AT us, but cuff is not.

Forearm is going AWAY from us.

Pant cuffs should radiate around shoes

USING THE CORE

A common mistake when posing characters is to have the arms, legs, and head do all the communication of the pose while the midsection (pelvis to torso) is straight as a board. A straight midsection or core can make your poses feel stiff. Also, you can miss out on a stronger way to communicate the emotions of the pose.

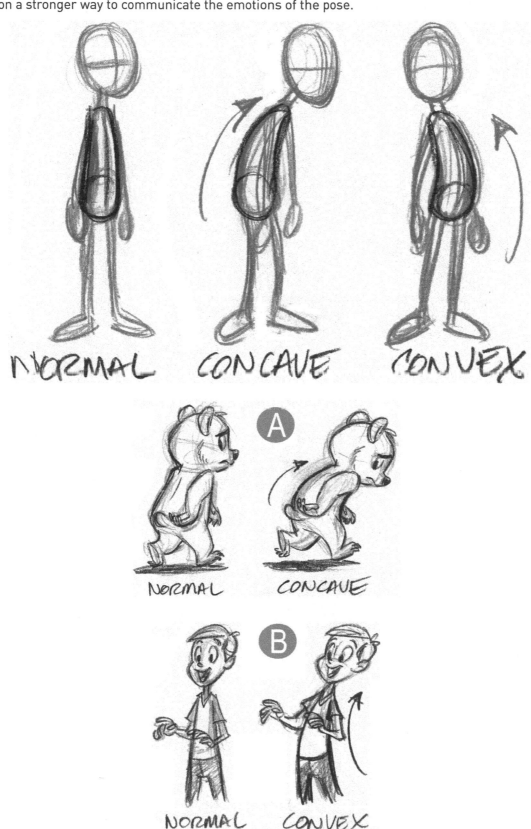

NORMAL CONCAVE CONVEX

A

NORMAL CONCAVE

B

NORMAL CONVEX

LINE OF ACTION

The imaginary line that can be drawn through your character's pose from feet to head (or through the arms, depending on the pose) is called the "line of action." In a dynamic pose, like a character punching another character (Figure A), the line of action is strong and clear if the poses are pushed. Straight, boring poses don't have a dynamic line of action, as seen in this "fight scene" in Figure B.

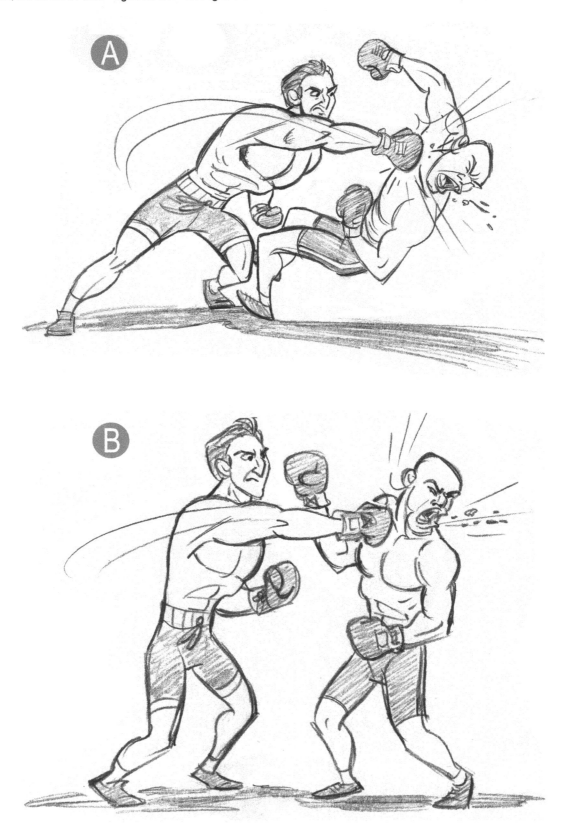

Additionally, there is a natural "flow" within the anatomy of your character when you have a strong line of action. It will also give your characters a sense of power and dynamics.

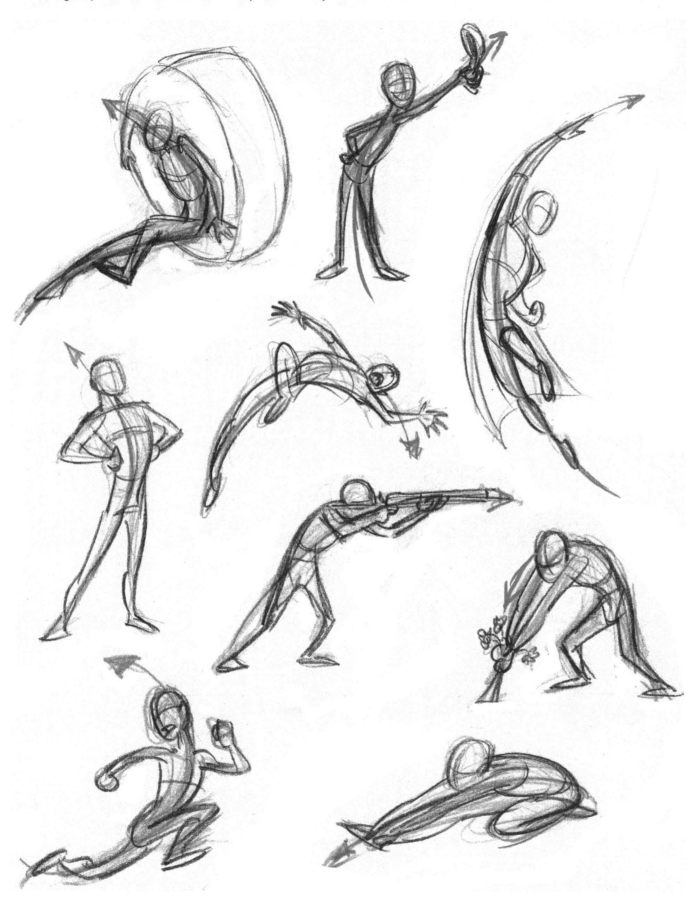

DRAMA IS NOT VERTICAL

To go along with the idea of a line of action in your character's poses, remember to draw elements within your pose at angles to create a more dynamic pose. A shape that is at a 45-degree angle, for example (Figure A) is more visually dynamic than a shape that is at a 90-degree angle (Figure B).

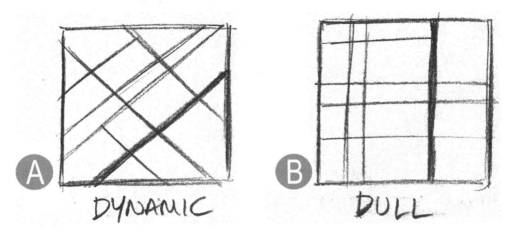

It's too easy to draw a straight up and down pose for your character. Try and push yourself to add angles into the drawing whenever possible. You will see this in superhero comic books in particular. Here are some stick figure–style poses with some of the straights taken out and replaced with some angles. More dynamic?

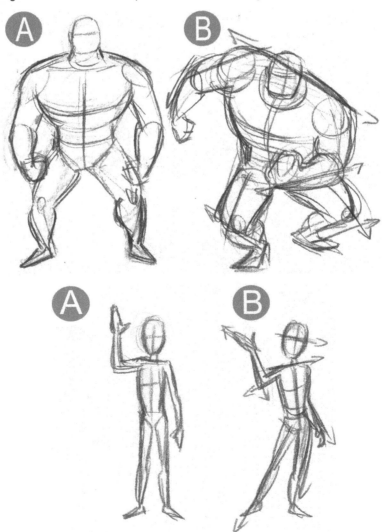

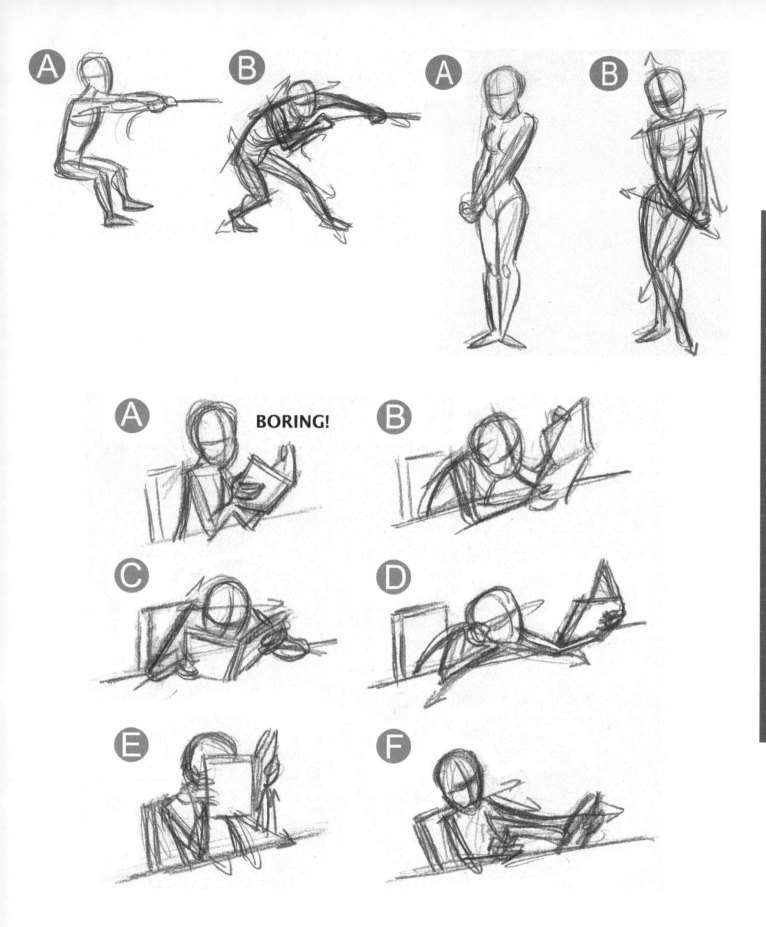

BORING!

STEP-BY- STEP: CREATING A POSE FROM START TO FINISHED COLOR

This might be a good place to stop for a moment and go through a pose-based illustration from start to finish to see how I would approach it. I always learn from seeing other artists' processes, and I think you might get something out of this that you can apply throughout this book.

I gave myself a simple assignment to create a spot illustration of a woman jumping out of the way of something – possibly reacting to someone throwing a firecracker at her. My goal is to create a pose that expresses a powerful leap but also has a strong sense of fear to her facial expression.

Here are the steps I took:

1. I create a quick sketch that is mostly just a line of action with simple shapes on top of it to show her basic anatomy. I'm going for a feeling here – almost like the pose is an exclamation mark. I use a red, erasable pencil to sketch this out. There is no real reason for the color red, but I do like using a color for my sketch so that I can clearly see the changes/final line when I add the black graphite in step 6.
2. I like where the sketch is going, so I stay with it. I add some more details, still using just basic shapes: ovals for the eyes and nose, a shape for the mouth. And I indicate the drag of her long hair, which also accents the movement.
3. I continue to add details. Refining her clothes (and the sense of drag on them). I start figuring out her expression more, too.
4. Because the sketch is far enough along to see some problems creeping into the drawing, I do what I do to most of my drawings – I flip it over. Looking at a drawing backward (via a light box) always helps me see the problems of a drawing. I create a new sketch on the back of the paper, fixing problems I see, like the lower foot placement, the tilt of the chest, opening the hand on one of the arms, and even redrawing the tilt of her head.
5. Flipping the drawing back the original way, I redraw the drawing, transferring the corrections I made on the back. They are minor tweaks, but they helped.
6. Using a kneaded eraser, I "knock back" the red underdrawing (which simply means I lighten the line by hitting it lightly with the eraser). Then I start creating my final, tighter line drawing with a graphite pencil. I want the final line to still feel loose, so I keep it slightly sketchy.
7. After I've drawn everything in the tighter black line – adding little details like hair strands and highlights in the eyes – I scan the drawing into the computer. This step enables me to go into the Channels box and select the Red channel, which takes out all the red line underdrawing, leaving only the tight black line. I then tweak the levels and contrast a bit until I have a final, tight black line. Ready for color!
8. In Adobe Photoshop, I start adding color. On a separate level, I cut out a shape for the background color and fill it with a gradient. I start with the background color simply because I already know that I want it to be a reddish-orange to give a sense of danger. Establishing the main color first is usually a good idea so that you can make sure everything else goes with it.
9. I add a white level (in the shape of the figure) in between the line and background color levels. This step gives me an opaque surface to work off of so the girl's colors aren't affected by the background colors.
10. At this point, I start blocking in flat color for her. Not all of them are completely flat; in a few places I use a gradient, like for her hair and blouse. There are a million different ways to color this piece, but I wanted a simple, "animated" coloring style for this that I thought would suit the linework style.
11. The last step is to add another layer that has some highlights and darker shadows that are applied graphically. Also, I make a last-minute decision to move her left arm down a bit so that the two arms weren't twinning so much. I should have caught this earlier (around steps 4–7) because changing it in the color stage is more work. With that change made, the drawing is done!

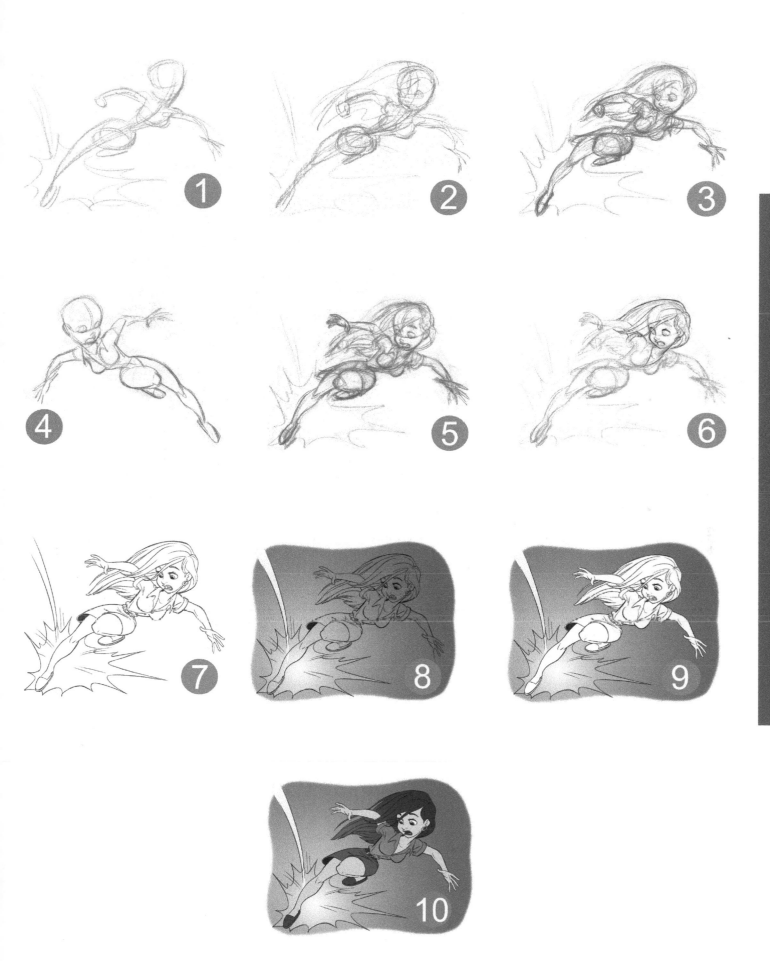

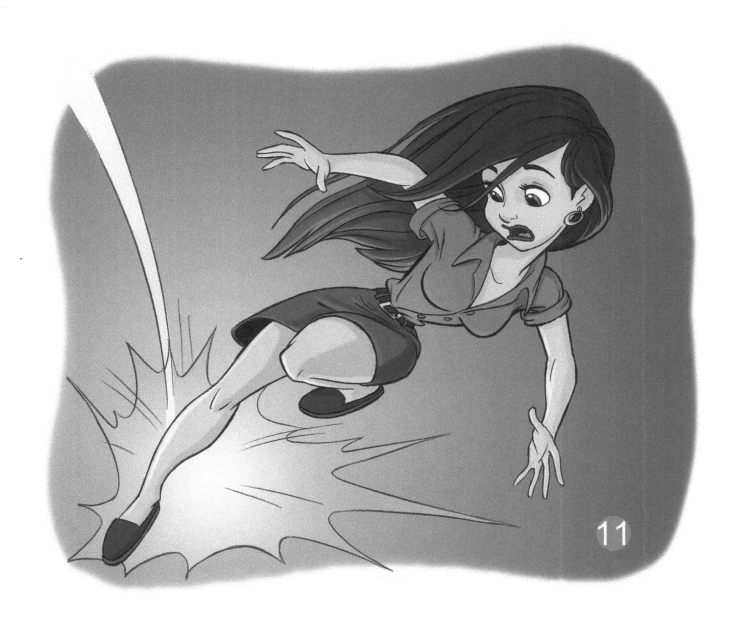

CHAPTER 1 NOW WHAT?

The most important element to creating a successful pose of your character is clarity. "Clarity" refers to the ability to be able to clearly understand the intent behind the pose – or the ability to "read" the pose. I have learned through the years that the first thing to do to create a good, useful, clear pose for whatever situation I need it for (comic strips, comic books, animation, illustration, or storyboards) is to take a moment and think. If I think about what I need the pose to communicate, that will eliminate many different poses and give me a feel for what I need to prioritze. Is the character pointing at something? Is my character sad and crying? Does the character want to show something to someone? Remember that there is always a reason for a pose, and if there is not, then do not draw it. It will be emotionless and without direction.

With this tip in mind, I think the best way to illustrate this point is to list a reason for a pose with a "right" and "wrong" version for each situation. One element that will always help strengthen the pose clarity is to have a strong silhouette value to the pose. Silhouette value is easy to see if you turn the paper you've drawn on over and shade in the pose with a dark pencil. All the negative shapes (the areas in between the lines of the character) will be white and will either help or hurt the clarity of the pose. Making sure that the hands, legs, and head are clear of the torso area is the easiest way to make a clear silhouette. If the character is holding something, that also should be kept away from the body whenever possible. I have shown the silhouettes of the poses below – right and wrong – so you can see why I have made the changes I did.

Pose suggestions/motivations:
- Picking a quarter up off the ground

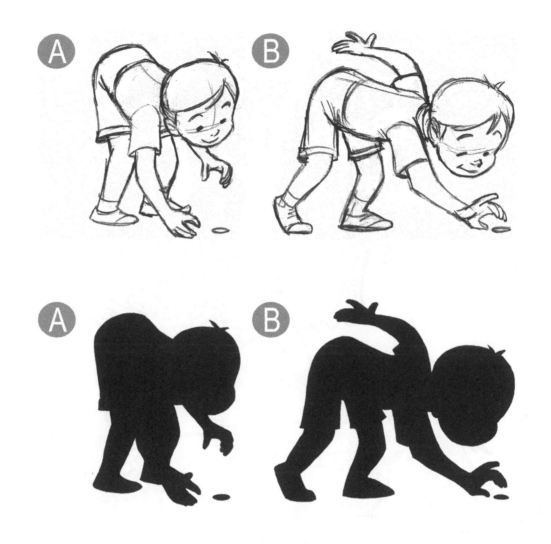

- A hungry bear about to bite into a sandwich

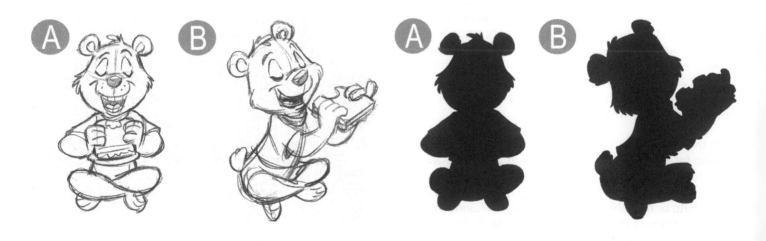

■ A superhero midflight, seeing something of concern below

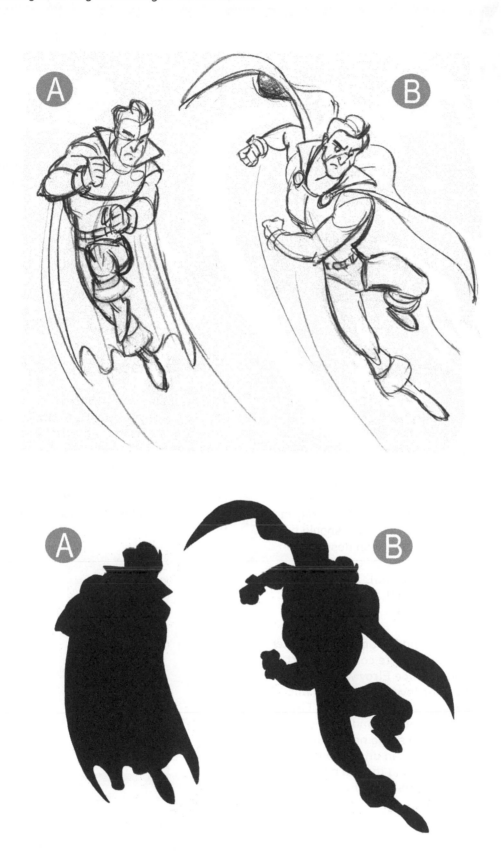

 # ASSIGNMENT #1

For review purposes, let's start with designing a couple original characters. Please keep in mind the elements of size and shape relationships to maximize the design. Designing characters and putting them in a strong pose is a lot to think about at once, so I suggest that you create the characters first, then put them in a pose. It's the drawing of them in a strong pose that I want to see from you.

The assignment is to create a teen boy and his pet/sidekick. Imagine that you are designing them as the main characters for a new TV show. They need to stand out and look like the stars of the show.

Character Descriptions

Elroy Chadsdale – A 15-year-old teen from England who has recently relocated to Northern California. Because of the move and the fact that he speaks differently from every other fashion-conscious teen at school, he comes off goofy and dorky. He is shy around girls, average at school (before discovering the necklace), and often kind of clumsy. He doesn't have many friends, so he sneaks his pet hamster in his hat for company – even at school. He should be thin, have big feet and hands, a largish nose, wear "unique" uncool clothes, and have a "unique" hat (that can fit/hide his hamster friend). Think of Harry Potter in the first film or the kid that played Young Sherlock Holmes for design ideas.

Kirby – Elroy's pet hamster and best pal (named after Jack Kirby, Elroy's all-time favorite comic book artist). They've been together since Elroy was a lad and are inseparable. Kirby's one love is eating. He will eat anything, but especially loves to nibble on Elroy's clothes. This is a constant problem and makes for Elroy always having to explain some new hole in his shirts, pants, and so on. Elroy can understand – and talk to – Kirby once he is wearing the tiki necklace. As it turns out, Kirby has an Irish accent and the temper to go with it!

The Show Concept

It's an action-comedy show for preteen kids. It is about an average, slightly geeky English boy, along with his pet hamster, who discovers an old mine shaft containing a long-lost tiki necklace. When our hero wears the necklace, he is empowered with the knowledge of the universe. With this god-like knowledge, he is able to change the world! That is, if his mom, dad, teachers, and school principal will listen to him.

OBJECTIVE ▷

The assignment is to create one final drawing of the two characters together in a pose that shows their relationship and, hopefully, a little of their personalities.

EXAMPLE #1
Pasqualina Vitolo

MENTOR NOTES

Out of the drawings submitted, I selected this character design by Pasqualina Vitolo (#1) because she approached it in a bit more of an anime/semirealistic style, which I thought would give me a challenge. And it did. I created one version that I felt was too far away from her design – it had too much of my style/preferences in it. That's not what this assignment is about, so I redid it trying to stay closer to her style. With this version, I looked at her size relationships and broke down the shapes she used to create her version. I then roughed out some thoughts on what I might want to push (drawing #2). From a shape standpoint (the place I always start), I liked what she did. My biggest suggestion is to make a slightly larger head and a bit more of a defined shape to it; I went with a triangular shape because her design already had that feel. Some other minor tweaks: I lowered the tiki necklace so that it would not be so evenly placed in his chest, tried to get a little more chest and waist to his design so that his torso section wasn't so tube-shaped, added a bit more neck, and made the shape of his hat a little flatter. With those notes in my head, I created drawing #3, which is generally the same design I roughed out but with a few things tweaked even further (like making his eyes a bit larger). The big push in drawing #3 is his pose. I didn't understand Pasqualina's pose the first time I looked at it, but then, after a while, I realized that Elroy was nervously waving at Kirby, who was being grumpy/angry. What seemed to be missing was some solid eye connection between the two and a bit better silhouette. I turned Elroy away from us a bit so we could see more of Kirby (who's angry because he is holding on for dear life) and tilted Kirby's head to be even more directional. Last, I gave a bit more perspective to Elroy's feet so he would feel more firmly planted on the ground. Thanks to Pasqualina Vitolo for her hard work!

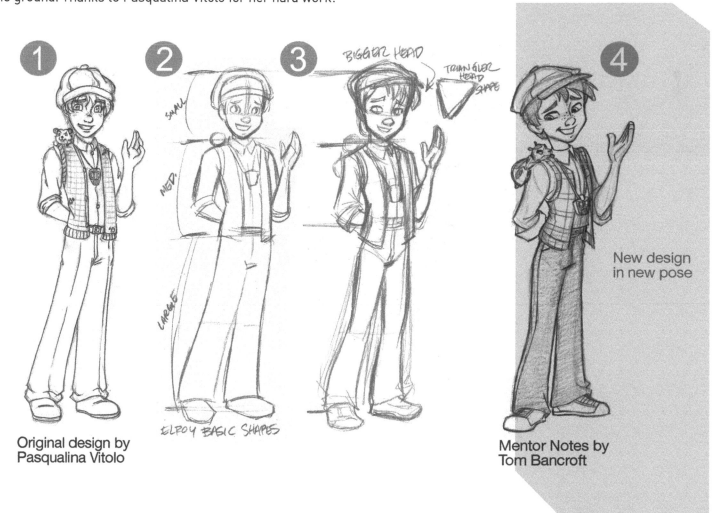

Original design by
Pasqualina Vitolo

New design
in new pose

Mentor Notes by
Tom Bancroft

EXAMPLE #2
by Ole Christian Løken

MENTOR NOTES

I really liked the character that Christian put into this drawing. There is a definite style to his design too, which is great. When I went over it, my first two goals were to (1) make Kirby the hamster much smaller and less shaggy and (2) strive to make Elroy a bit more of a lanky teenager, like in the description. I also tried to make his proportions a bit more varied, as Christian's design was a bit even. You can see that in drawing #2, where I went over his design and broke down the shapes and spacing. I tried to stay within his style (as much as I could) while simplifying the linework, as this is supposed to be for a TV series. Extra linework would kill an overseas animation crew and cost more to the production, which are two big reasons for the simplification. Also, streamlining a design is important so that as many people as possible can "understand" how to draw your character, which will happen when it goes to an overseas animation studio. I noticed that Christian's style had straights and curved lines throughout, so I tried to retain that in my design. I will say that I went back and forth on Christian's chin for Elroy. I liked it quite a bit, but ultimately, felt it made him feel older, so I left it out of my version. As with any character design, there are so many different ways to approach a design. There are many different ways to make a successful Elroy design, so please accept these notes as "something to chew on" and not the final word/version. Thanks to Christian Løken for his great submission!

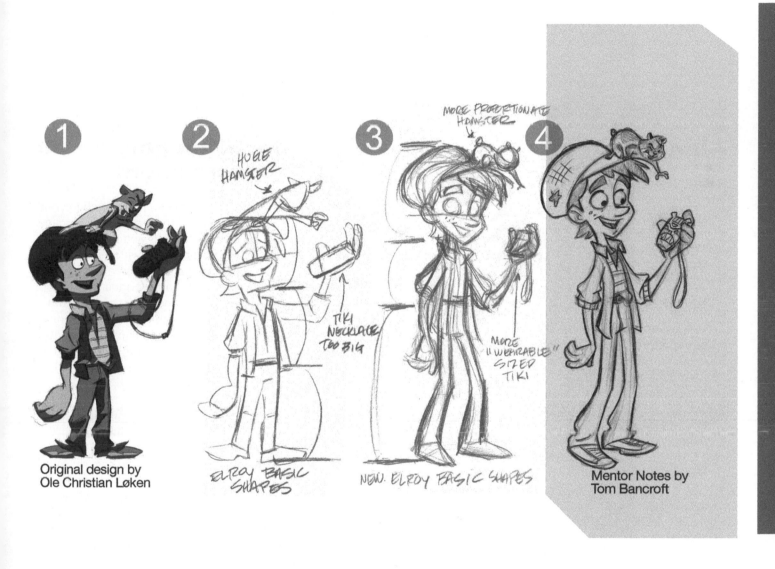

1 Original design by Ole Christian Løken

2 HUGE HAMSTER

TIKI NECKLACE TOO BIG

ELROY BASIC SHAPES

3 MORE PROPORTIONATE HAMSTER

MORE "WEARABLE" SIZED TIKI

NEW ELROY BASIC SHAPES

4 Mentor Notes by Tom Bancroft

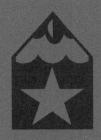

CELEBRITY ARTIST ASSIGNMENT
BOBBY RUBIO
STORYBOARD ARTIST

About Bobby

Bobby Alcid Rubio was born and raised in San Diego and has been drawing since he was a child. He attended the California Institute of the Arts in Valencia and earned his Bachelor of Arts Degree in Fine Arts. After graduation, he worked for Homage Studios (Image Comics) in La Jolla and then continued on to pursue a career in animation. Bobby worked for nine years with Walt Disney Feature Animation as a traditional animator and storyboard artist on several films, including *Tarzan* and *Treasure Planet*. After Disney, he worked as an assistant director/storyboard artist for Nickelodeon Animation Studios on the series *Avatar: The Last Airbender* for two and a half years. Currently, Bobby is a story artist for Pixar Animation Studios and has worked on the animated short "Tokyo Mater" and the feature animated movies *Up*, *Cars 2*, and *Brave*. After hours, he works on his creator-owned and independent comic series *Alcatraz High* and *4 Gun Conclusion*. For more information, visit his website, bobbyrubio.com.

His Thoughts on the Assignment

As a story artist, it is my job to create a feeling with an image. The image should be clear and recognizable in an instant. So with this assignment, I wanted to create a creepy vibe. Tom had provided the character design and layout of the room. Emma's design was so sweet, innocent, vibrant, and animated; I wanted to contrast her with the mysterious shadow figure. So I made him more stoic, dark, and creepy.

Emma is the focus, so I placed her in the foreground. She is happily texting away on her mobile phone, completely unaware of her stalker. The stalker is in the background, and I have created several visual cues that lead the eyes to his direction. The ceiling lines converge and point to the window, as well as Emma's feet, her bed, and her jeans on the floor. With this dynamic shot that I designed, I hope that I have conveyed the feeling of creepiness that I was alluding to.

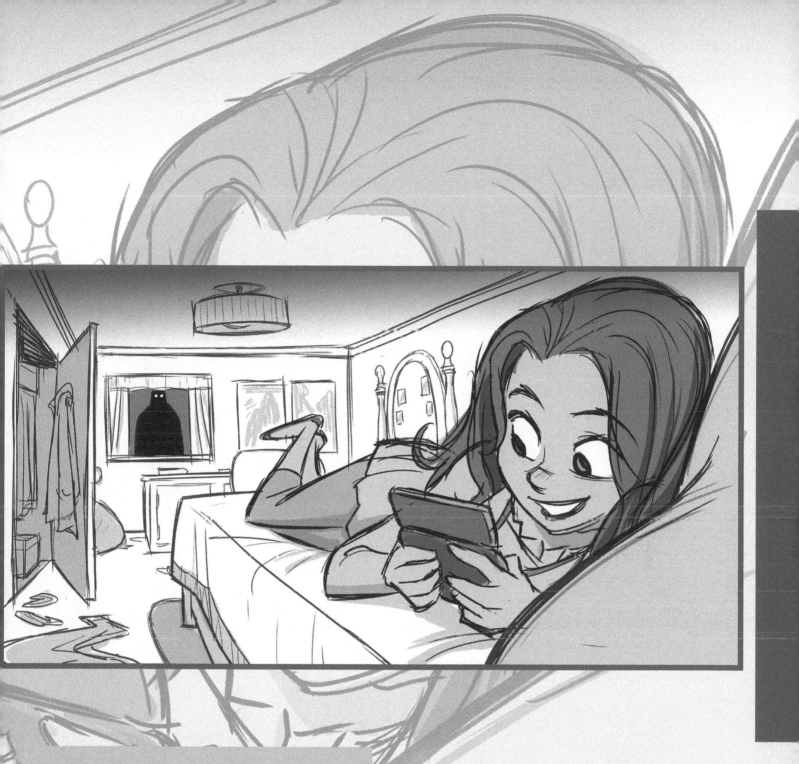

READER NOTE

Please see page 141 for the description of assignment #6. All celebrity artists have created artwork with the same guidelines given in that assignment so that we can see their equally strong but varied approaches to the same challenge.

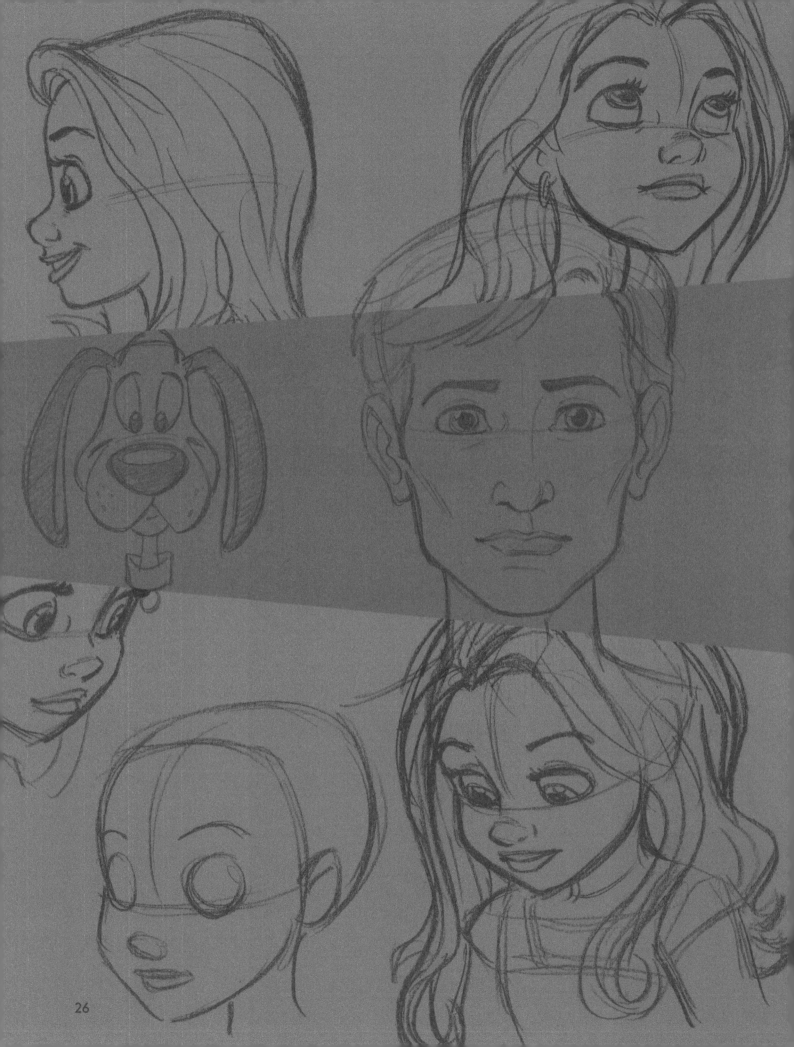

26

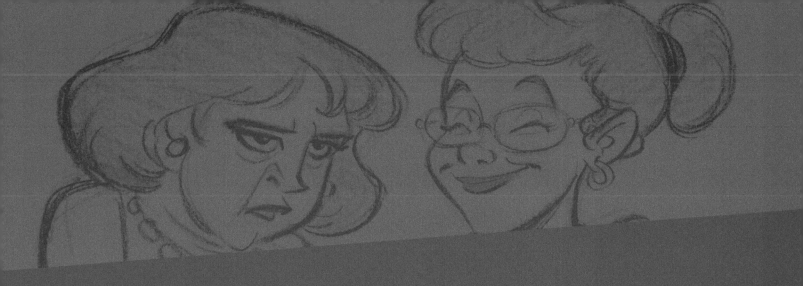

CHAPTER 2
THE FACE
Breaking Down the Elements of Expression

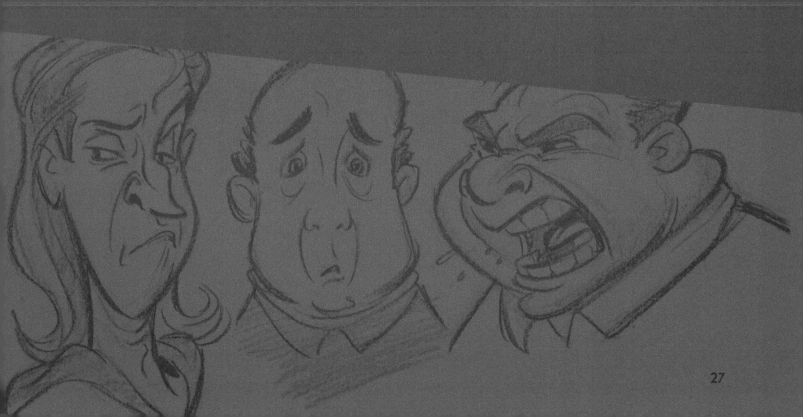

THE FACE 2

Acting Elements of the Face

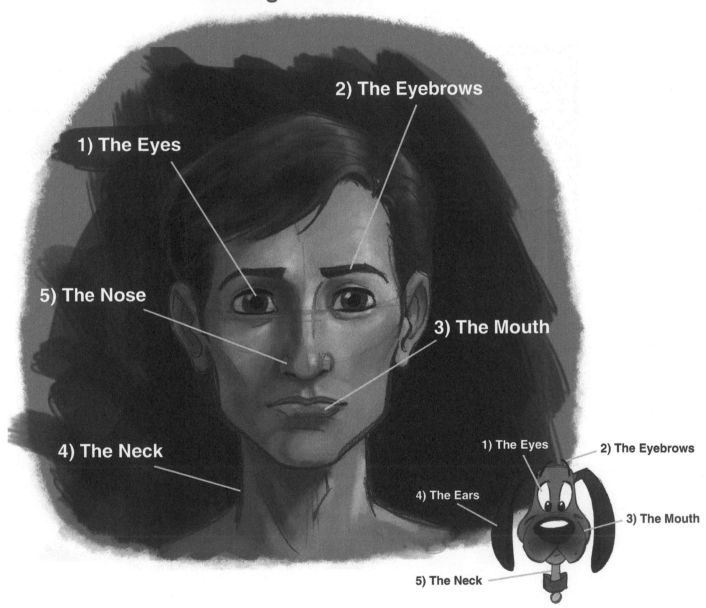

2) The Eyebrows

1) The Eyes

5) The Nose

3) The Mouth

4) The Neck

1) The Eyes

2) The Eyebrows

4) The Ears

3) The Mouth

5) The Neck

1 = most important to 5 = least important.

In this chapter, we're going to start looking at the basics of character expressions. I want to continue to stay general at this point; in later chapters, we will get specific on what and who your character is. After that, we will concentrate on figuring out why your character is doing something. For now, these are still generalities about how faces work (male, female, or whatever) and how to "push" your character's expressions.

First, let's look at the elements that make up the face – both human and animal – showcasing their individual importance in communicating to an audience through emotion. These are just my personal opinions here – you may rate their importance a bit differently. Also, depending on the expression, I might put them in different order. For simplification, I am using a male face to represent a human face as the representation of a human, but the same evaluations would apply for any humanoid character – females, children, and everyone. I've thrown in a cartoon dog to represent most anthropomorphic animals (cats, horses, lions, etc.) to make a point that there is an added feature they have that can emote.

The EYES	"The window to the soul." We are taught from birth to look into each other's eyes when we communicate. When an actor is in a tight close-up on-screen, we will look into the eyes first and foremost and then, peripherally, look at the mouth for emotional cues.
The EYE-BROWS	Almost as important as the eyes because the eyebrows put the clarity into what the eyes are trying to say. If the eyes are the "windows," the eyebrows are the "curtains"!
The MOUTH	The eyes and eyebrows do all the "heavy lifting," but the mouth is nearly as important for defining that exact expression you want to illustrate.
The NECK	Yep, the neck beat out the nose for emoting – and the nose is in the middle of your face! This is because a tilt of the head sometimes says it all.
The NOSE	We don't usually use our nose to convey emotion. Like our ears, it serves a more practical purpose. If you make a very extreme expression, though, it can be hard not to furrow your nose.

This cartoon animal diagram is here to make the point that with some animals, the ears can help show emotion. Ears up can mean "happy or inquisitive"; ears down can mean sad or introspective.

I think it will be useful to go through each facial element listed in the diagram and point out some tips to remember about them separately before we start combining them in our expressions.

EYES

I mentioned in my first book (*Creating Characters with Personality*, Watson-Guptill Publishers) to always strive for variety in your eye shapes. Circular, almond, and teardrop shapes – among others – can help show different personalities or ethnicities of your characters. For now, let's just use a rounded, simplified eye shape for these examples.

Remember that eyes are round shapes that have skin and muscle round them. It is that muscle and skin around our eyeballs that gives each of us our unique eye shapes. We can see less than one-third of the surface of the eyeball, so keep in mind that there is much more behind the eye than what we see.

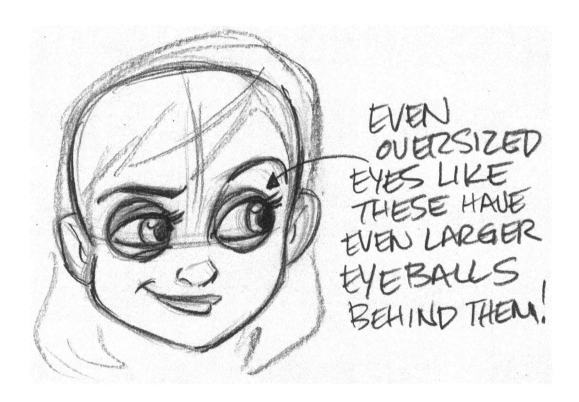

EVEN OVERSIZED EYES LIKE THESE HAVE EVEN LARGER EYEBALLS BEHIND THEM!

Keeping in mind this fact will help you accurately show the pupil shape to convey eye direction as they *curve around the circular form* of the eyeball.

Unfortunately, sometimes frustrating eye problems pop up when you are trying to get just the right expression or "look" on your character's face. We have all been there, and we have sketchbook pages or art boards that are reduced to shreds with all the erasure marks to prove it! There are a few things you can keep in mind to help fight these problems. Here are a few of the eyeball culprits and some thoughts on how to fight them.

Zombie Eyes

"Zombie eyes" is my term for that blank stare that a character gets when the pupils are dead-on, smack dab in the middle of the eyes (Figure A). Very rarely do you ever want to use this expression. This look works for a shocked look or some kind of strange sick look on your character (Figure B). See the figures below for some good and bad examples. If your character needs to look at the "viewer," then turn the head slightly so you don't get the "zombie" look (Figure C).

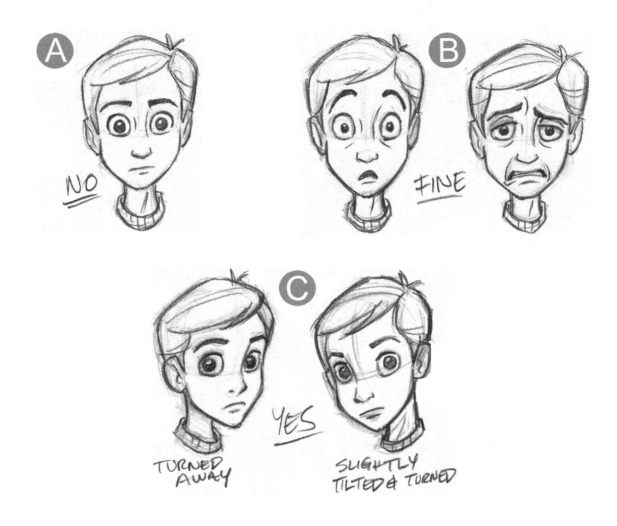

Walled Eyes

Walled eyes are part of the look made famous by Matt Groening on the TV show *The Simpsons*. But even *The Simpsons* stopped doing it after the first few seasons of the show. This look is achieved when the characters pupils are independently looking away from center, in different directions. Walled eyes are a funny, bizarre expression, but if your character has them all the time, you can't get any real emotion or eye direction out of it. Apply the earlier note of imagining arrows coming out of your characters' eyes to clear this up.

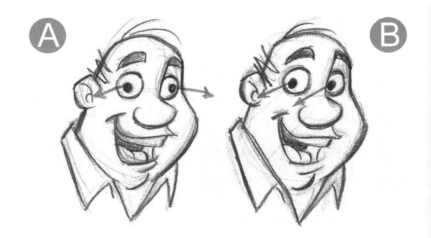

Crossed Eyes

As with the two previous examples, it's amazing how easily this look can creep up on you. Crossed eyes are just as they sound: the pupils are turned inward, toward each other (Figure A). Watching for this is the best way to prevent it. How you draw the pupils can help prevent this problem in most cases. One of the hardest things to have a character do without creating crossed eyes is look at their own nose (Figure B). Remember, as stated earlier, the eyeball is round – not flat. When you draw a pupil looking down or inward, flatten it a bit (making it oval) to show the slight perspective of the curve of the eye. This trick will help ease the look of crossed eyes (Figure C).

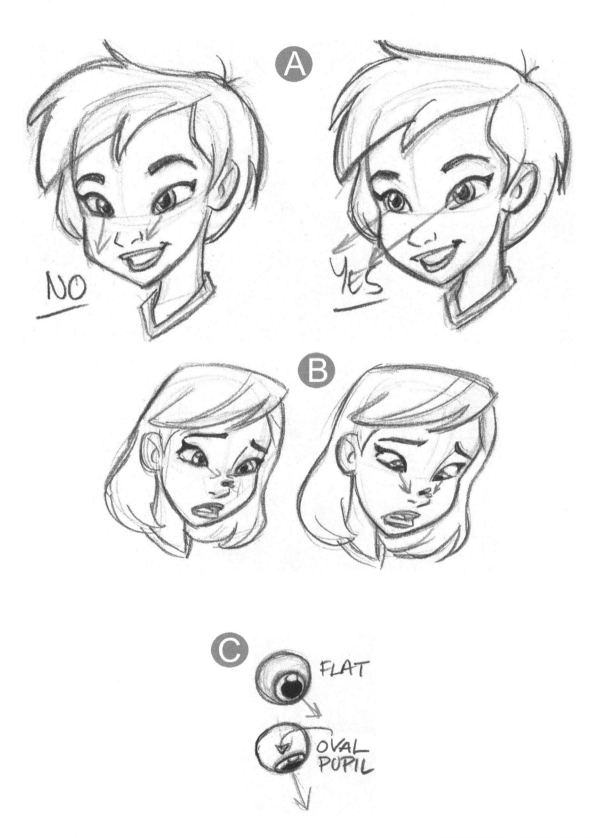

EYEBROWS

Even with a strong cartoon style or simplified character, it's important to establish a connection between the eyes and the eyebrows. For example, if your eyebrows are placed too far away from the eyes (as with a character with a huge forehead), you will lose the relationship of eyebrow to eye and how they work together. Not making them feel connected will weaken your expressions as well as make the eyebrows feel like they are floating on the face – not connected via skin and muscle underneath.

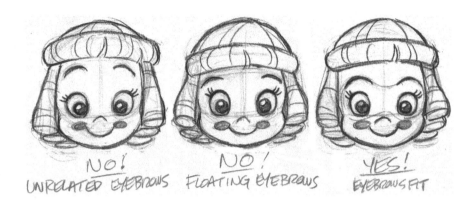

A good way to make sure the two facial pieces relate is to lightly sketch in a Lone Ranger–style mask around the eyes. The mask will help you lock the eyebrows above the eyes and show them with proper perspective. Remember to draw the curve above the eyes with a feeling for the brow that comes out over the eyes; this approach will give you more feeling of depth.

The face mask becomes especially helpful when creating expressions. Remember that the eyes react to what the eyebrows are doing. Look for those opportunities to show that by compressing or stretching the mask shape.

THΣ MOUTH

Here's another analogy to illustrate the importance of the mouth in the facial expression hierarchy: if the face were a sentence, the eyes would be the noun, the eyebrows would be the verb, and the mouth would be the punctuation. Why? Because the mouth helps define the emotion behind the expression. Here is an experiment you can try on your own. Draw a face with just the eyes and eyebrows drawn in. Do about six of them, all with different eye expressions. Do they communicate the expression clearly?

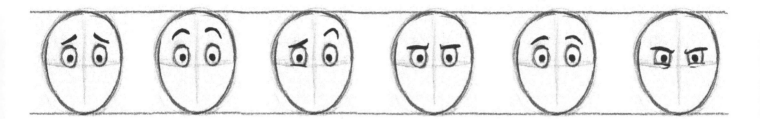

Yes and no, right? They communicate the most obvious emotion. Or maybe you read one emotion, and I would see something different. Your mind fills in the mouth that it most commonly associates with that particular eye expression.

Here are some of the same eye expressions with mouth shapes added that seem to fit. Is this the facial emotion you pictured?

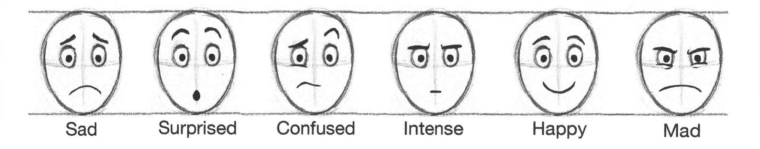

| Sad | Surprised | Confused | Intense | Happy | Mad |

But, to get a bit more subtlety and variety, try some different mouth combinations and see what emotions you get. For fun, try more and see how far you can go.

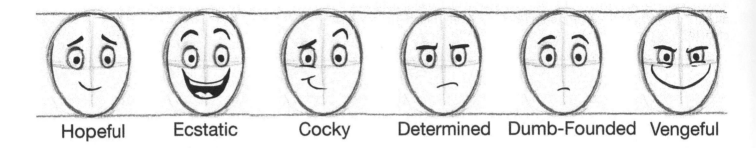

Hopeful Ecstatic Cocky Determined Dumb-Founded Vengeful

Different mouths project slightly – or very – different emotions. That's why the mouth is the question mark or exclamation mark of the "emotional sentence"!

Additionally, remember that the mouth and jaw work together. Many artists forget to extend the shape of the face when opening the jaw. This method is especially useful when animating dialogue mouth shapes.

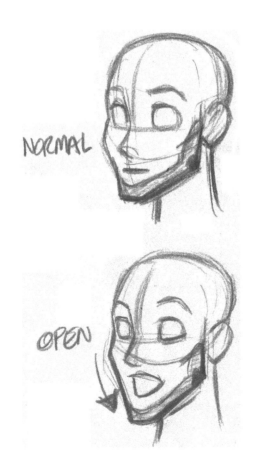

NORMAL

OPEN

THE NECK

Though not actually part of the face, I learned early in my feature animation career that the neck and more specifically, how it relates to the head, was an important tool to help your character come to life. In short, I discovered the dynamic world of head tilts. In some instances, a head tilt can strengthen a pose by making the line of action less vertical. Angles are more dynamic. But that's just one strength to "head tilts." The real strength is in how certain poses more clearly communicate the story idea or emotion via a head tilt.

Which one of these communicates the action or emotion better?

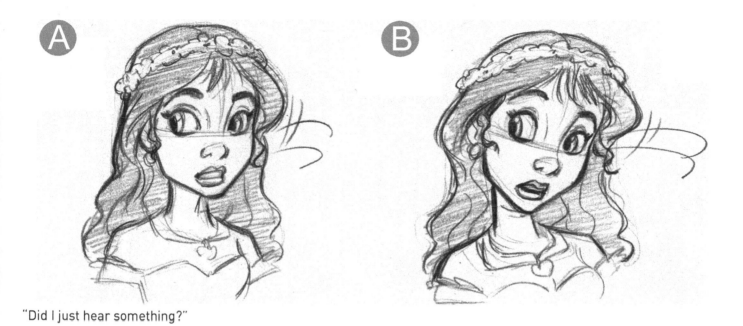

"Did I just hear something?"

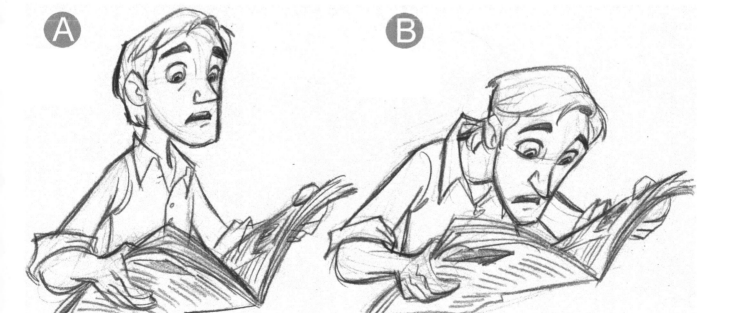

"What does that say?"

THE NECK

And for adding to expressions, a head tilt is often the icing on the cake of a pose or expression. Here are a few examples – you can decide which communicates the best.

WITHOUT WITH WITHOUT WITH

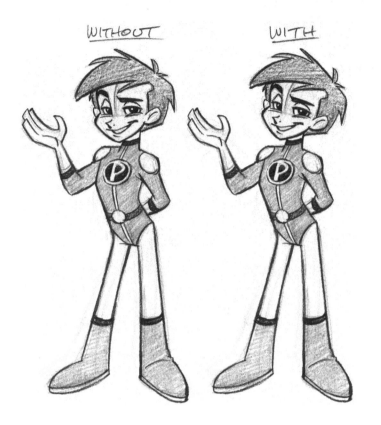

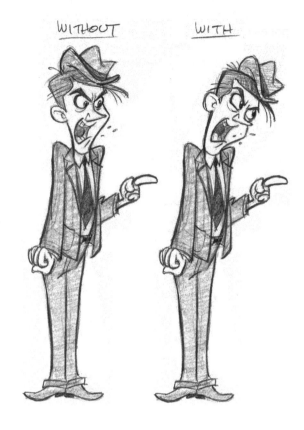

WITHOUT WITH WITHOUT WITH

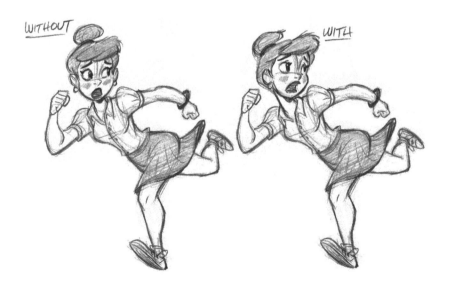

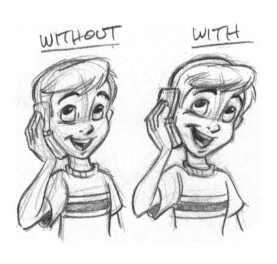

THE NOSE

To go back to my sentence structure analogy: The nose would be the semicolon. It's something you will rarely need, but it can be a strong accent in those rare occasions. The more anatomical or realistic your character, the more you will use the nose in expressions. Here are a couple of expressions in which the nose is useful as an accent.

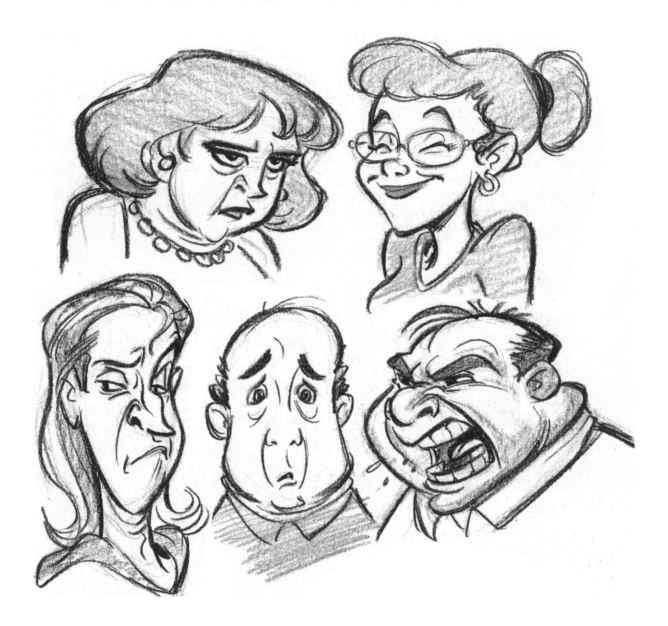

USING THE FACIAL ELEMENTS TO EMOTE

Now that we have dissected the facial elements (and neck), I want to concentrate on how they work together to convey an expression.

You have seen the expression charts in other cartooning books, right? They are very useful, but the *most* useful tool you have in making your characters come to life is *you*. Whenever I get stuck trying to find an expression for my character to express a certain emotion, I pick up a mirror and act it out. If your character is mournful, for example, do not look in the mirror and make the "sad" look from the expression chart. Think of a situation that makes you feel the way your character needs to feel, then feel it. *Now* look in the mirror. You will probably find an original or unique way to portray that emotion – and I guarantee it will be a more subtle acting solution.

I like to challenge myself by using an existing character design (in this case, "Tommy" from page _____) and try to create a variety of ways to express different emotions. Here are a few that I've drawn. Try it yourself with your own character; you will discover a new level of subtlety in your character's personality.

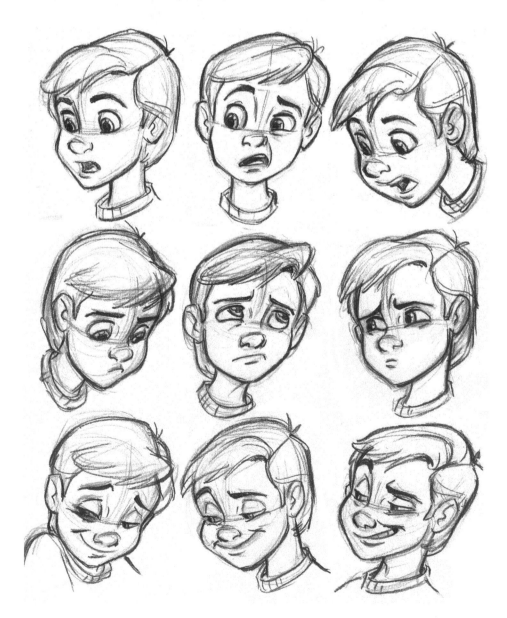

Pliability in the Face

One of the best of the original Disney animators of the 1930s and 1940s was Freddie Moore. The other animators of the time would say that Freddie *could not draw a bad drawing* if he wanted to! Every sketch he made was appealing and filled with charm, even though Freddie was largely self-taught. It was natural for him. That appeal came into play when the studio decided to create the first ever feature-length animated film: *Snow White and the Seven Dwarfs*. With his fun, appealing, cartoon style, Freddie was quickly tapped by Walt Disney to supervise the character design and animation of the seven dwarfs.

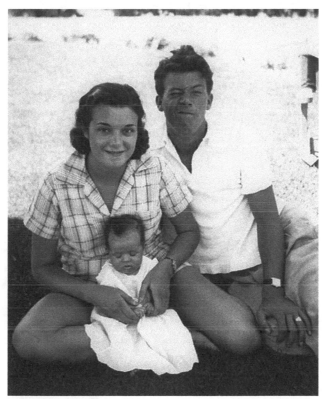

An early photo of Freddie Moore and his family. Here he models "pliability" in the face perfectly!

It's hard to imagine this, but most of the animation concepts – and character drawing concepts – that we use today in our drawings were *created* in the 1930s. Freddie Moore was one of those pioneers, and he was just doing what *felt right* to him. He started drawing the dwarfs with a flexibility to their cheeks and a spongy feel to their bellies and fingers that made them feel more real – not stiff drawings anymore. Walt noticed this and had the other animators look over Freddie's shoulder to see how he was making his dwarf drawings come to life. The key difference was that Freddie was adding a concept we now call "squash and stretch" to his drawings – especially in the fleshy areas of the face and body. This change in shape from one drawing that was compressed and round to the next being stretched long gave a *pliability* to the face and

body that had not been seen before in animation. This is not an animation book, but giving your still drawings a sense of pliability is still important. You will get much more feeling of life and movement to your drawings if you consider that the shapes you are working with have girth, weight, and flexibility. For example:

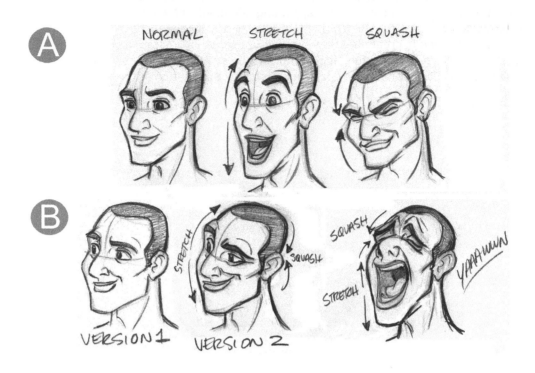

As you can see in Figure A above, there is no squash and stretch applied to the face. This lack of pliability makes for stiff facial expressions. In Figure B, there is much more life to the drawings and expressions. Remember, as mentioned before, the jaw moves up and down, which naturally lengthens the face when your mouth opens.

Additionally, even a lean character should have some movement in the cheeks.
A heavyset, fleshy character will have even more extreme movement to the cheeks – and therefore, more reaction in the eyes. We have the ability to move our mouths around our face because of the muscles beneath our skin, which makes for more interesting facial expressions. As you can see in the figure below, version B has a sideways smile that makes for a bit more personality and life in the face. This effect shouldn't be overdone, but occasionally and for certain characters, a good crooked smile does wonders!

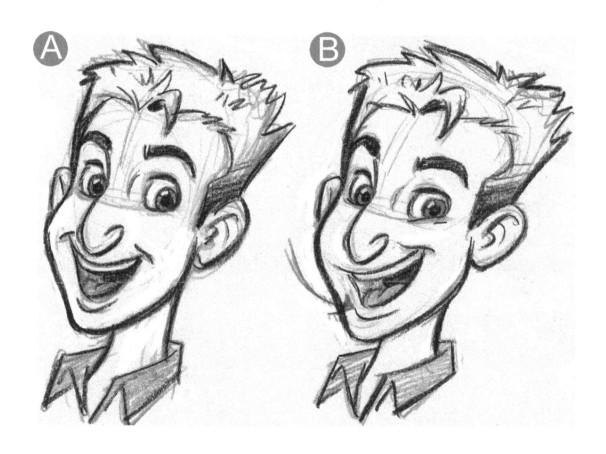

ASSIGNMENT #2

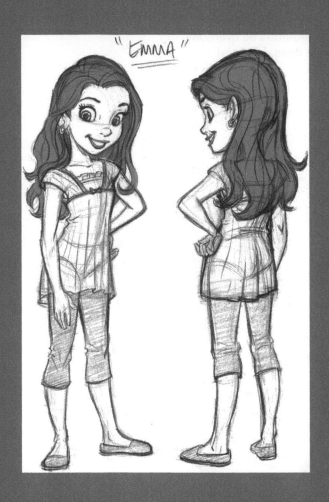

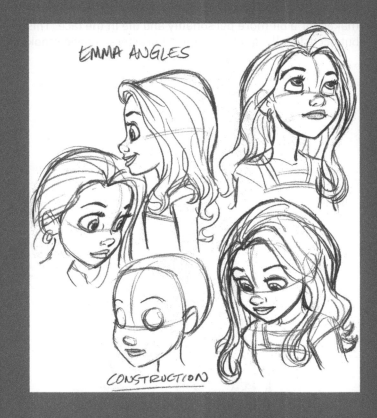

Review the "Emma" model design and additional head sketches. Just using the head and neck, create six drawings of "Emma" in different basic expressions. Remember to consider her "fleshy" cheeks as she grimaces or grins. The eyes should react to the cheeks. How do the eyes react to what the eyebrows are doing? Do your best to stay "on-model," which means staying true to the design on the model sheet provided. One of the hardest things you can do as an artist is replicate a character in different angles and different attitudes yet still successfully make him or her look like the same character. That is a big part of this assignment.

Because who she is will affect how she acts, please take into consideration this basic description of her character.

Emma – Age 12, the kid at school who has many friends. She is warm and optimistic – to a fault. She can easily get her feelings hurt because she is such a "giver" that her expectations are that people will do the same for her. Often, they don't. She is easily taken for granted because she is "always there" for her friends, which makes her even more of a pleaser personality. Get her mad and she can change into a fiery beast that takes a while to cool. Because of her optimistic personality and faith in those around her, she can be naïve and easily duped. Generally, though, she is full of love and smiles.

These are the emotions to illustrate: (1) normal happy (content), (2) angry, (3) nervous, (4) surprised, (5) sad, and (6) scared. Please arrange them all on one page, using the template provided.

EXAMPLE #1
Francisco Guerrero

MENTOR NOTES

I really liked Francisco's drawings and the emotions he put into them. My biggest notes/suggestions revolved around how Francisco used the body/neck in relation to the head. If you look at Francisco's drawings, most of them are very straight up and down (the head-to-body ratio). And the shoulders are straight across. I tried to push the emotion a bit more in my notes by using the body, neck, and head tilts a bit more. Also, I tried to widen the eyes or compress them more depending on the emotion. "Scared" is a good example of this. Francisco's felt a bit more like "concerned" than "scared," to me.

Expressions Submission by Francisco Guerrero

Normal- happy

Angry

Nervous

Surprised

Sad

Scared

Expressions Mentor Notes by Tom Bancroft

Cheeks and Eyebrows up

Grin off to side for variety

Normal- happy

Cheeks push up

Head Turn

Angry

Tilt head

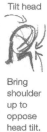

Bring shoulder up to oppose head tilt.

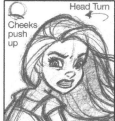

Nervous

Stretch face more

Eyebrows up

Cheek down

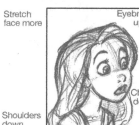

Shoulders down

Surprised

Tilt head down

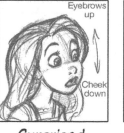

Sad

Droop hair

Eyebrows up

Head back

Shoulders up

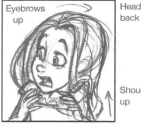

Scared

EXAMPLE #2
Lauren Draghetti

MENTOR NOTES

Lauren did a nice job capturing Emma's personality and trying to keep her as on-model as possible. I think keeping a character on-model is very important and, truthfully, a part of this assignment. You should always try and make the character look like the model sheet when given one by an employer, so this was good practice for Lauren to do just that. As far as how she captured the emotions, I thought she did a fine job, but there was room for improvement here and there. First, the "surprised" expression she drew is hurt by it being a profile view. Yes, you see the mouth open very clearly in this angle, but she really doesn't get the most out of the expression – especially the eyes – from this view. With "surprised," you can move her head either forward or back, but it should not be vertical to the body. It just doesn't express the emotion if she's not leaning in one direction or the other. Same with "scared," in which more

Expressions Submission by Lauren Draghetti

Normal- happy

Angry

Nervous

Surprised

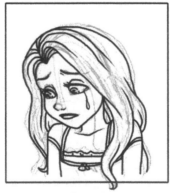

Sad

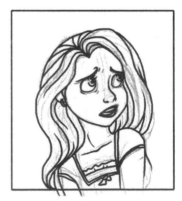

Scared

often than not you would cower back, not move forward toward whatever you are afraid of. Lauren's "sad" expression, as you can see, I changed very little because I thought it worked well. I mostly just dropped her shoulders and had her hair move forward from gravity. Doing that helps accent her mood, too. Also, I really liked her "nervous" and tweaked that only slightly. I felt her body could be twisted away from us more and I liked the idea of her biting on her pinky to accent her nervousness. Pretty much all of Lauren's poses had the shoulders up, which for emotions like "happy," "sad," and "surprised" seemed like the opposite of what you would want to portray, so I dropped the shoulders on those emotions in my notes.

Expressions Mentor Notes by Tom Bancroft

More directional with one eye wider than the other

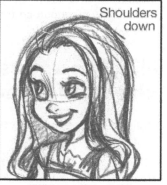

Shoulders down

Normal- happy

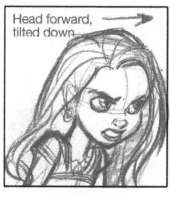

Head forward, tilted down

Angry

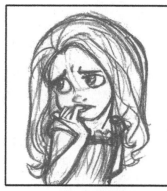

Biting on finger

Turn body away a bit

Nervous

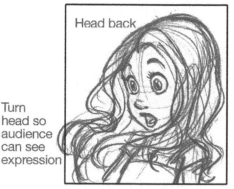

Head back

Turn head so audience can see expression

Surprised

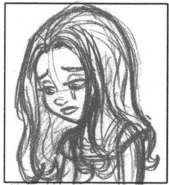

Hair falls forward

Sad

Slump shoulders

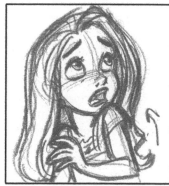

Shoulders and eyebrows up

Scared

CELEBRITY ARTIST ASSIGNMENT
SEAN "CHEEKS" GALLOWAY
COMIC BOOK ARTIST/CHARACTER DESIGNER

About Sean

Sean Galloway is a self-taught artist who became a professional in 2004. He soon catapulted to lead character designer for the Sony Pictures Television animated series *The Spectacular Spider-Man*, providing the defining look and style of the cast of characters.

Prior to his work on *The Spectacular Spider-Man*, Galloway lent his artistic talents to several comic books, as a penciler for Marvel Comics' *Venom*, cover artist for *Marvel Adventures*, and a cover artist for DC Comics' *Teen Titans Go*, as well as interior art for many other Marvel and DC projects.

Other film and TV projects include: creating storyboards for *G. I. Joe Renegades*, *Scooby-Doo Mystery Inc.*, and as a conceptual artist for both Disney's *Tron Animated* and *DreamWorks Mastermind Projects*. Additionally, Galloway was character designer for the films "*Hellboy Animated: Sword of Storms*," and "*Blood and Iron*."

Some of his game and toy design work has been for Blizzard, EA, Sony Entertainment, Phoenix Age, THQ, Hasbro, Upper Deck, LeapFrog, and Wildstorm/Blizzard.

On the side, Sean works on his creator-owned properties: "Bastion's 7," "Gumshoes 4 Hire," and "Little Big Heads."[1]

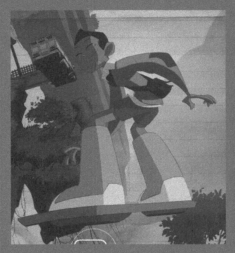

Sean's work and updates can be found at: http://cheeks-74.deviantart.com/gallery/, http://gotcheeks.blogspot.com, http://twitter.com/cheeksgalloway, and http://www.facebook.com/sean.cheeks .galloway.

His Thoughts on the Assignment

I look at every task in the face and show it who's boss! I say, "Task, you take-a what's o' coming to ya. Any peep outta ya and I will make ya feel my wrath!"

After we are on the same page, I try to lay out the page, keeping in mind what is important to communicate – like keeping the important parts visible, clear, and with a twist of voilà.

What I wanted to go for in this image is to show how into texting the main character is, all the while not noticing she has a stranger at her window.

(I created this digitally on my Cintiq using Adobe Photoshop.)

[1]Bastion's "7 Gumshoes 4 Hire," "Little Big Heads," and all related characters trademarked and © Sean Galloway. All rights reserved 2011.

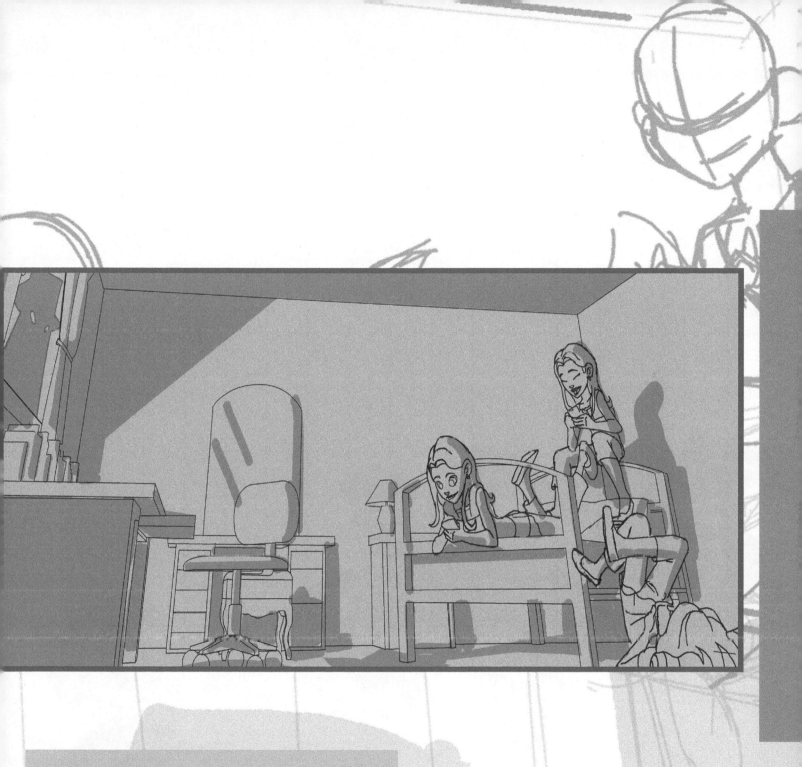

READER NOTE

Please see page 141 for the description of assignment #6.
All celebrity artists have created artwork with the same
guidelines given in that assignment so that we can see
their equally strong but varied approaches to the same
challenge.

CHAPTER 3

POSING YOUR CHARACTER

What are You Trying to Communicate?

POSING YOUR CHARACTER 3

In this chapter, as with expressions, we are going to take a general look at the uses of posing your character before we get into more specific elements of a character's personality. The question for this chapter is: what is the purpose of the pose?

Most poses can be broken into four different categories based on their purpose or need:

STORYTELLING

or "acting poses." These are poses with a point. Storytelling poses are expressive poses used to convey a character's emotions – even without them having to speak. These poses are the essence of body language and show a thought or emotion.

DYNAMIC

or "action poses." These include any pose used to show a character looking courageous (as in superhero comics) or movement poses that describe what a character is doing.

DISPLAY

These poses are best described with the classic "ta-da!" pose, with arms thrown out to the side, chest out, and a broad smile on the face. Display poses are predominantly used in merchandising art or other venues when the need is to show the character front and center, as an icon. Usually no story is behind the pose – it's just: "I'm happy, love me!"

ALLURING

or "sexy" poses. Just like display poses, this is really a subset of either a storytelling or dynamic pose. But it is such a specific – and well-used – style of posing that it deserves its own category. A famous artist once gave this advice: " If you can draw pretty girls, you'll never go hungry."

Of course, a pose and expression combination can have elements of a few of the posing categories listed here. If I were drawing a comic book panel that had a character running from someone/something but also looking back to his friend to give him some encouragement, that pose would be both a storytelling *and* a dynamic pose.

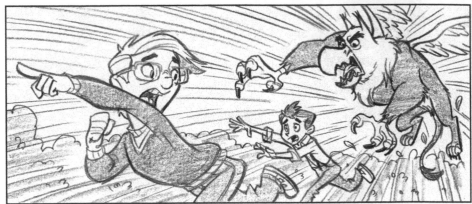

STORYTELLING/DYNAMIC

Here's an example of an alluring and a storytelling pose:

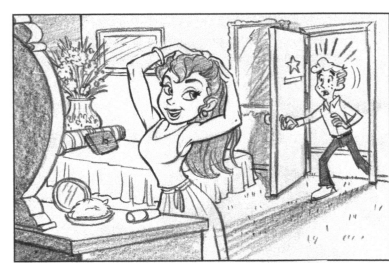

ALLURING/STORYTELLING

In commercials, you can have many examples of display and storytelling poses:

DISPLAY/STORYTELLING

BODY LANGUAGE

When I was working at Disney, I found out a secret that some of the more experienced character designers and animators know that they won't tell you. It's something you have to find out on your own. I had gotten to the point in my career at Disney that I was involved in some of the meetings with upper management ("the suits") at which we would present development art and preliminary character designs (some drawn by me) and try and get their input or approval. We would pin up various different versions of our character, and they would walk by them eyeing them closely. If they slowed in front of one of the drawings, we would get excited, hoping that *that* drawing might be approved and become the final version of the character we've been trying to design for months on end! That was the routine – for almost a year, in some cases – as we would try and get things approved but more often than not be sent back to our drawing tables to figure out a new version of that character for next week's management (non)approval meeting. After a while, other artists started getting strong responses and approvals on their character design drawings, so I started to analyze what they were doing that was different from what I was doing. That's when I discovered the secret! It didn't matter how great a face, costume, nose, armor, or whatnot I put into my character design! What mattered to the suits, nonartists that they were, was *did it "feel" like what they thought the character should be*! I didn't need to do tight drawings, add color, draw bigger to fill up the board, or even do *more* drawings – I just needed to do drawings that had some kind of attitude to them! Not just well-designed character designs, but placing them in poses, with expressions, that said *who they are*! When I started concentrating on that, things went much better.

The following is of a girl that we can imagine is a character design of a heroine for a film or TV show. Her character is that she's a southern girl who doesn't realize how beautiful she really is. She is awkward and shy but with an inner strength that comes from her strong but strange family upbringing. Now, with that in mind, which one *says who she is* best?

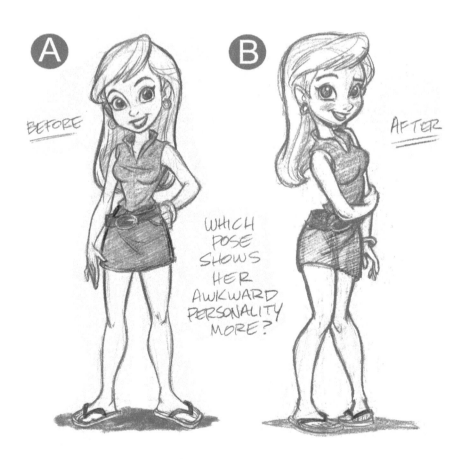

I have to admit that one of my artistic weaknesses is that I rely on my character's facial expressions too much. It is an easy problem to fall into. Sometimes a scene needs a close-up of a facial expression to best express the drama of the moment, but whenever possible, use a full body pose. So much is gained emotionally by using the body and the face together.

One thing I do to make sure I'm communicating the correct emotion with the character's body and not just his or her face is draw the face last. Once I've sketched out a pose, I take a moment and review it, sans face. Does the pose communicate the emotion I am going for? If not, I do some more thumbnail sketches until I have a pose I think is successful. At that point, adding the facial expression is like adding the frosting on a cake. It just makes it better!

Here are some rough poses I did with certain emotions in mind. Can you "read" the body language?

WEIGHT AND BALANCE

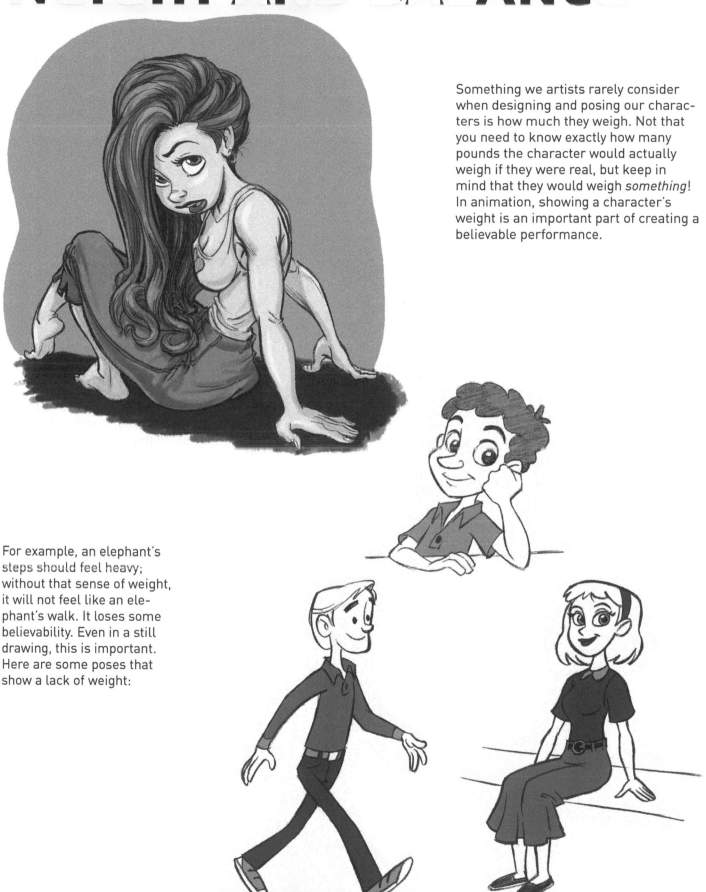

Something we artists rarely consider when designing and posing our characters is how much they weigh. Not that you need to know exactly how many pounds the character would actually weigh if they were real, but keep in mind that they would weigh *something*! In animation, showing a character's weight is an important part of creating a believable performance.

For example, an elephant's steps should feel heavy; without that sense of weight, it will not feel like an elephant's walk. It loses some believability. Even in a still drawing, this is important. Here are some poses that show a lack of weight:

One of the elements that are missing in those drawings is compression. *Compression* (or "squash," in animation terms) is the sag, spread, or squash – that we see in any shapes that have softness or some kind of kinetic anatomy. Here are two examples of compression:

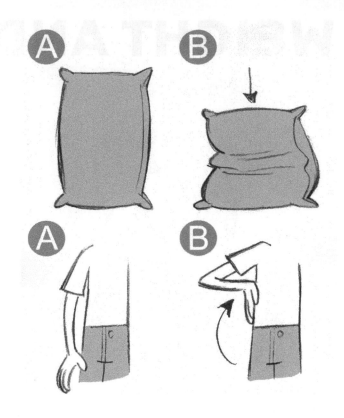

COMPRESSION IN HANDS:

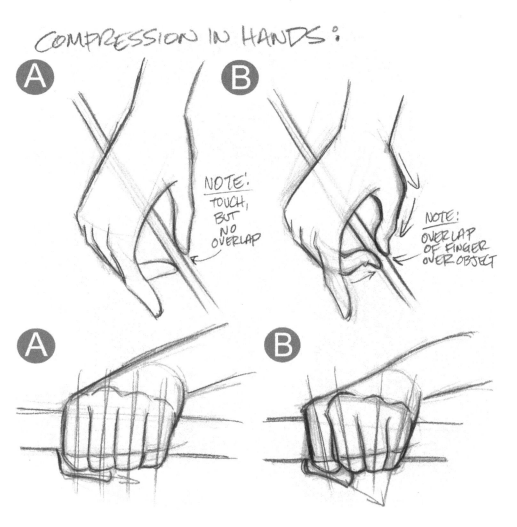

A

B

NOTE:
TOUCH,
BUT
NO
OVERLAP

NOTE:
OVERLAP
OF FINGER
OVER OBJECT

A

B

A

B

The obvious areas you will see compression in real-life poses are in the fleshiest parts of our bodies, like the buttocks (when we sit), cheeks, or belly of an overweight person. Keep in mind that compression does not always refer to the fat, fleshy areas of the body, but also in how we draw the joints of the hands, arms, legs, fingers, and feet of the body. We show weight by how we compress our fingers together, for example, when picking up a pencil. Even something as light as that needs to have some compression shown in the hand for the audience to be able to believe contact has been made by our characters. You see this in CG characters especially. It can be especially hard for a computer-animated character to look like he or she is actually holding an object. Part of this problem is the lack of compression in the hands. See the before and after examples in the following figure for how subtle compression can be in the hands.

On page 57 there are a few poses that show a lack of weight, and here is a second version where I have applied some kind of compression (highlighted in red) to show a stronger feeling of weight.

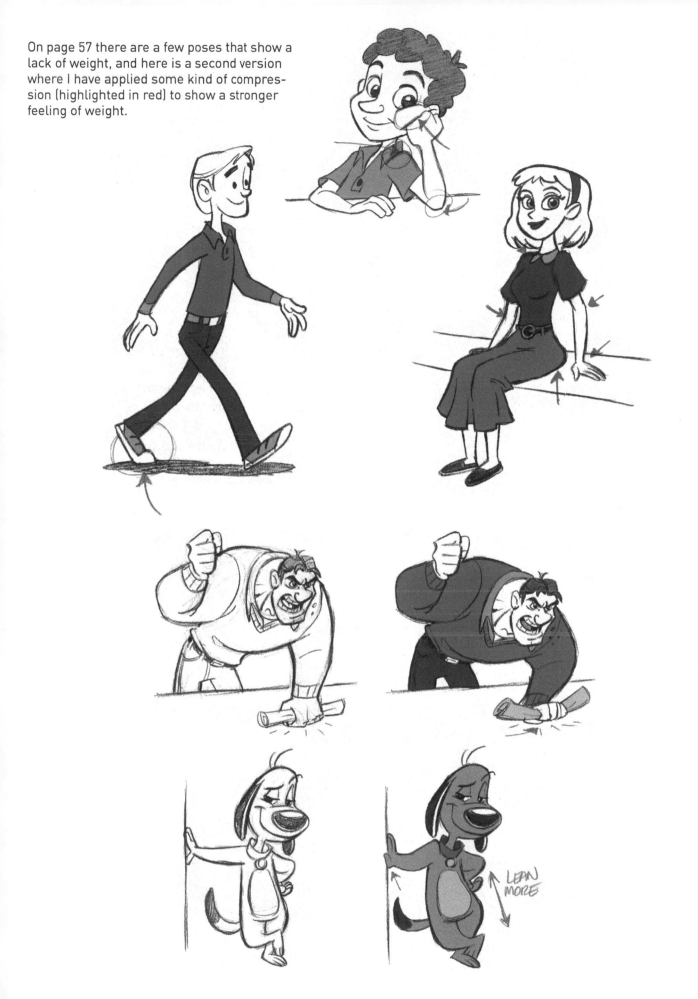

LEAN MORE

Another concept to help strengthen your poses as well as show weight is called *balance*. Whether you are a rocket scientist or preschooler, you know how a sense of balance affects a person or thing. If your pose is off-balance, it just won't feel "right" to the average person – even if they cannot explain why. That is because a sense of balance is a part of our earliest learning.

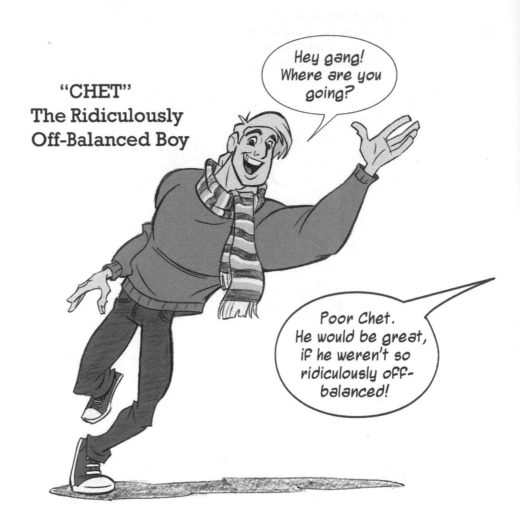

"CHET" The Ridiculously Off-Balanced Boy

Hey gang! Where are you going?

Poor Chet. He would be great, if he weren't so ridiculously off-balanced!

The most basic concept in creating good balance in your pose involves weight distribution. For a human character that means, for the most part, keeping the feet underneath the *majority* of the body weight.

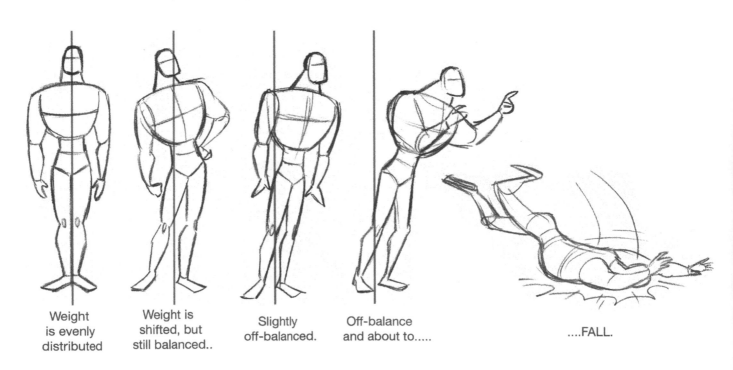

Weight is evenly distributed

Weight is shifted, but still balanced..

Slightly off-balanced.

Off-balance and about to.....

....FALL.

Usually, all it takes to maintain at least a feeling of balance in your pose is to *counterbalance* the weight shifts in your pose. The basic concept is that when one element of your pose is thrust in one direction, some other element of the body should move in the other direction to counterbalance your character.

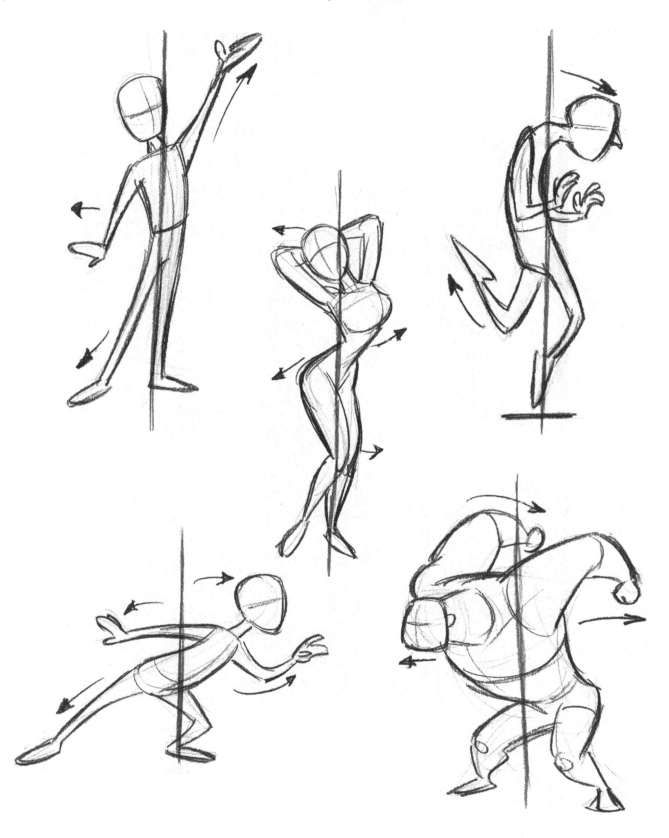

These poses use counterbalancing to distribute the weight more evenly.

THE MECHANICS OF MOVEMENT

A common question I have heard artists ask is, "How can I make my still drawings feel like they have a sense of *movement* to them?" It is not an easy thing to accomplish. As a Disney animator for more than ten years, I needed to study movement. The more you study any subject, the better you will be at it. I suggest you watch people, sporting events, and animal movement in order to make your characters feel more natural in their acting and poses. Another good way to learn is to act out your poses in front of a mirror. Take a mental picture, then draw what you saw. Analyze what every appendage is doing during the action.

Drag

Drag (in the context of this book) is an animation term that is grounded in physics. It refers to the loose, flowing elements of a character that drag – or follow behind – the main thrust of your character. A simple example of this is a ball that has a string attached to it. If you throw the ball, the attached string will drag behind the ball and describe the arc (or the trajectory) of the throw. Notice how, in the two examples in the drawing below, the string describes the invisible arc. Also note that the one with the straight string feels as though it is going faster. The straighter the line of the drag, the faster the main object seems to be moving. This is physics, too.

Figures A, B, and C shows the same pose of a boy running, but illustrating drag in three different ways. It has many components to drag: his hair, his shirtsleeves, the bottom of his shirt, and even – to a lesser degree – his pants. Which of the three poses feel like he is going faster?

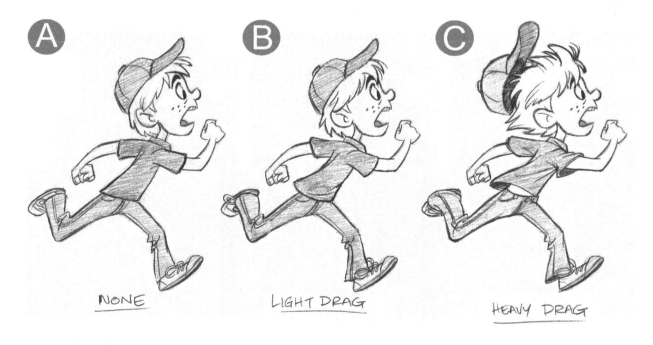

Drag can also apply to your character's pose. To create drag, you must have a main thrust that the lighter, thinner, longer, or lower-energy element is following. Momentum is an element that naturally creates drag within the human body.

Here are some pose suggestions and situations that I have illustrated with and without drag applied to the pose.

- A character who just got punched in the face:

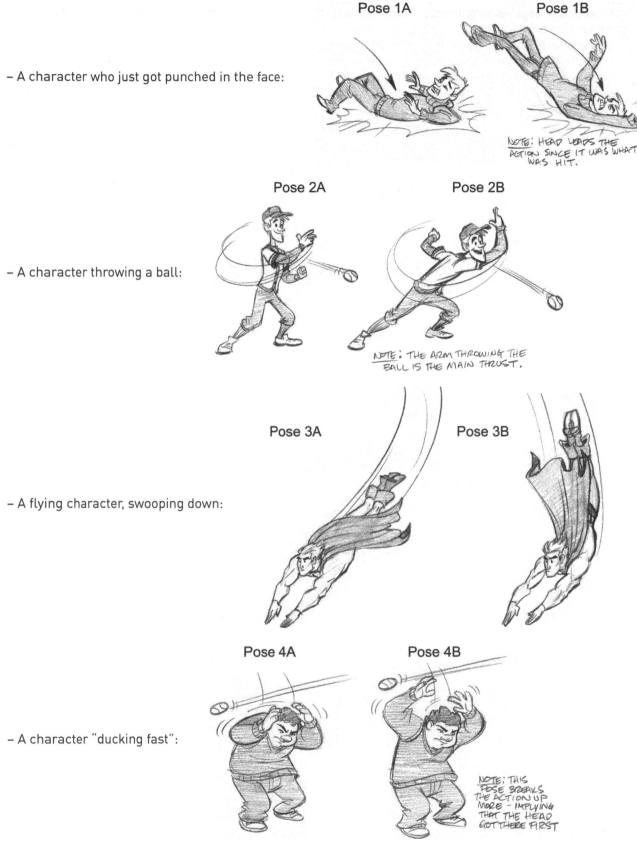

Pose 1A Pose 1B

NOTE: HEAD LEADS THE ACTION SINCE IT WAS WHAT WAS HIT.

Pose 2A Pose 2B

- A character throwing a ball:

NOTE: THE ARM THROWING THE BALL IS THE MAIN THRUST.

Pose 3A Pose 3B

- A flying character, swooping down:

Pose 4A Pose 4B

- A character "ducking fast":

NOTE: THIS POSE BREAKS THE ACTION UP MORE - IMPLYING THAT THE HEAD GOT THERE FIRST

The last example is subtler. It feels more like we are seeing something midaction rather than a finished movement. Sometimes that is the best way to think of your action to get a stronger action pose.

Considering the elements of momentum and drag will give your poses a greater sense of movement, weight, and believability.

WALKS AND RUNS

When I was at Cal Arts, learning the art of animation, an animation test our instructor gave us was to animate a character walking in place (also called a "walk cycle"). There are many complex body mechanics we had to learn to make the walk feel like it had weight, the arms were swaying a the correct speed, the body had a slight up and down motion to it, and the head had a very subtle bobble. I remember that test as one of the moments I realized how much one needed to know to make one movement look correct. As daunting as that test was, it wasn't until a few years later (with many walk cycles under my belt) that I was given an even more challenging assignment: start with a character in a stopped (standing) position and have it transition into a walk cycle. No problem, I thought – until I started drawing out the poses.

I tell this story because it illustrates one of the most common mistakes beginning animators fall into when animating walks and runs. To illustrate the problem, I will show you the first four drawings I did that day:

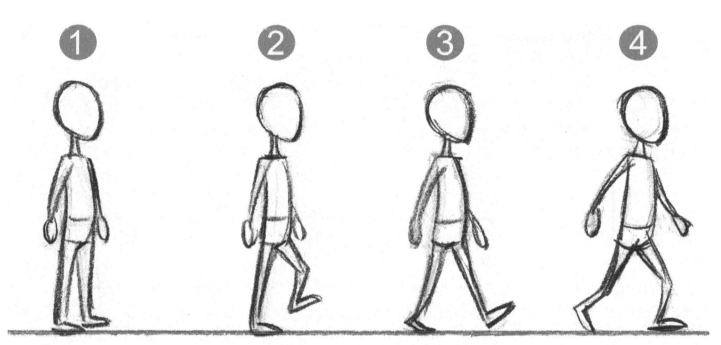

Start
Position

Do you see the problem? Neither did I, until I shot the drawings a frame at a time under a video camera and viewed the short film I had made. My little character was gimping awkwardly across the page! I scratched my head for a little while until later that day when I attended a guest lecture that was set up for our class. The lecturer was the amazing Disney animator James Baxter. Everyone was to find out just what a master he was, not only as an animator, but also at analyzing movement. His lecture was on the body mechanics used in walks and runs. He showed many clips of real people walking and running in different ways and – most enlightening to me – from stopped positions, too. He said one basic principle in that lecture that stuck with me and changed how I viewed walks and runs. He said that a character in a walk is actually *falling*. His point was that to propel ourselves forward, we have to gain momentum, which means we have to lean our bodies forward – rendering ourselves off-balance so that our legs *have to jut out in front of our body so we don't fall.* In the case of a run, we are hurling our bodies forward!

I went back and applied this newfound knowledge to my earlier animation mistake. The problem arises right away, in drawing #2. I was starting the action with the leg raising up; then, in #3 and #4, I have to have the body try and catch up to where the leg is planted. After reanimating it, this is what I came up with as a solution:

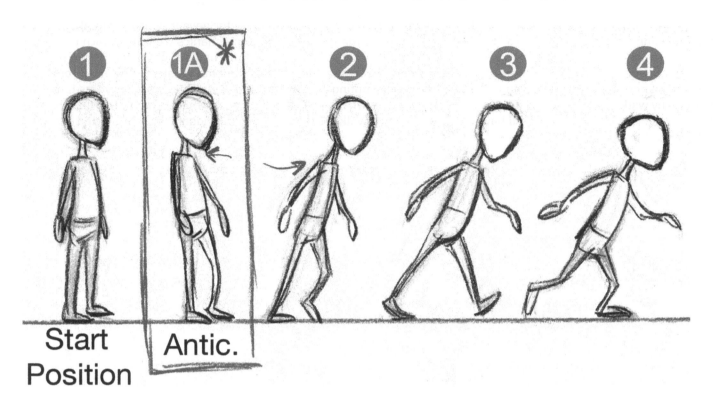

Start
Position

Antic.

Though it is not the point of this exercise, I added a pose, #1a, before drawing #2, because the action needs a slight "anticipation" – moving in the opposite direction to anticipate a move-ment – to make this walk work correctly from a stopped position.

In this new version, drawing #2 has the head/body leaning forward and leading the movement. Drawings #3 and #4 continue that forward lean/fall as the leg then picks up and moves forward. It worked!

Now apply that knowledge to your still drawing of your characters walking or running. The amount you lean your character will also help show the speed they are moving. Also note that the less your character's feet touch the ground, the faster they seem to be moving. Your fastest running pose should not have the feet touching the ground! The chart below is useful to review in gauging your character's "mood-to-pose ratio." Which pose fits the mood you feel your character should be in as they walk or run along?

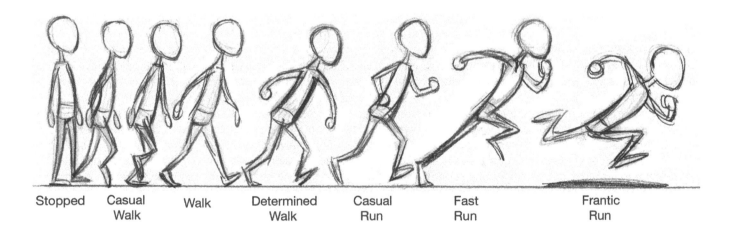

Stopped Casual Walk Determined Casual Fast Frantic
 Walk Walk Run Run Run

Finally, there are many different ways to show walks and runs. Try and break up the pose you put your characters in so they are not in the same "walk" pose or the same "run" pose. Here are some different ideas. Try a few of your own and see how many you can come up with.

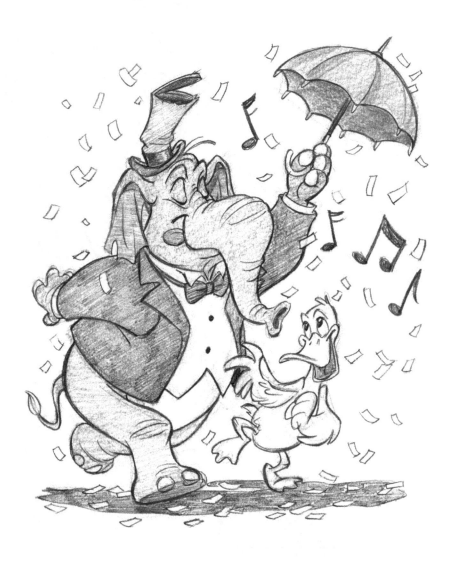

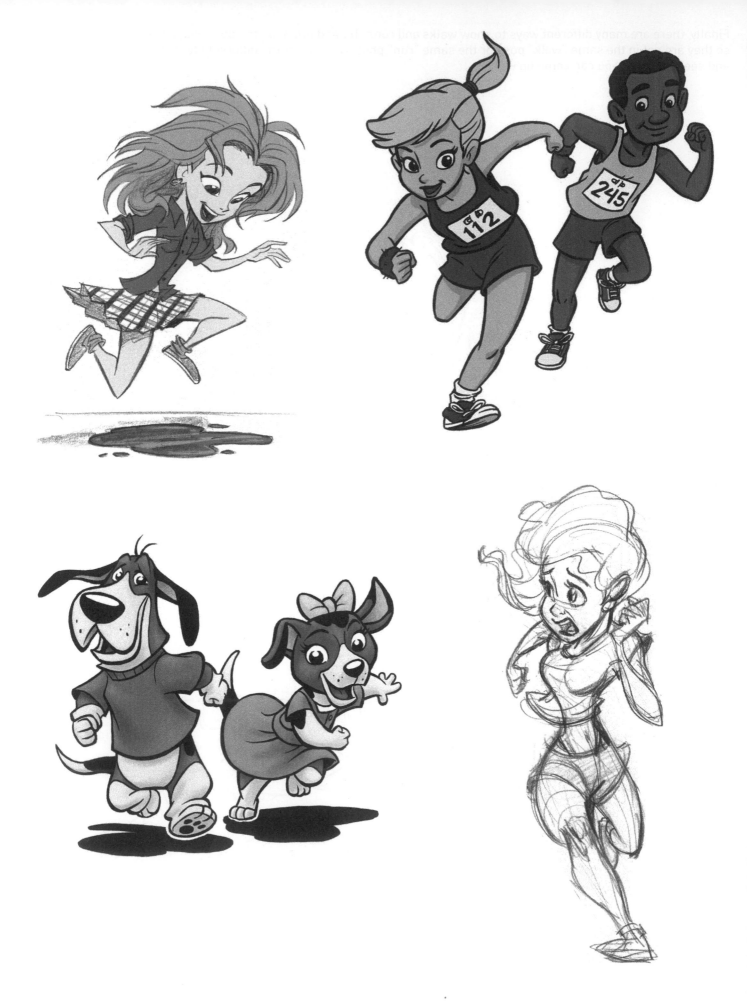

ASSIGNMENT #3

Here is a fairly simple, average-looking character. We'll call him "Tommy." This is his "turnaround" or orthographic model sheet to be used so that you know what he looks like from different angles. What I have purposely left out is any emotion. He's in a bland pose with a blank look on his face. I've also given you some drawing notes to show you the basic shapes used to help you replicate him.

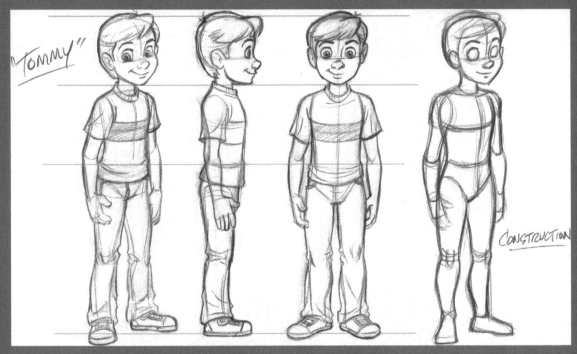

Using the model sheet of Tommy, please draw a full body pose sketch for each of the descriptions that follow. Have Tommy in a three-quarter angle, preferably with him looking at an imaginary person that is page left from him.

Keep in mind these things: the acting in his pose and on his face, some idea of perspective to his feet stance, a good silhouette to the pose, and a flow to the body.

Pose/emotion descriptions:

1. Tommy nervously handing a small, fragile vase to someone
2. Tommy confidently looking over at someone page left (trying to look cool)
3. Tommy sadly walking/turned away from women, but looking back (over his shoulder)

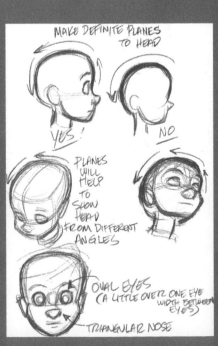

EXAMPLE #1
Elaine Pascua

Poses by Elaine Pascua

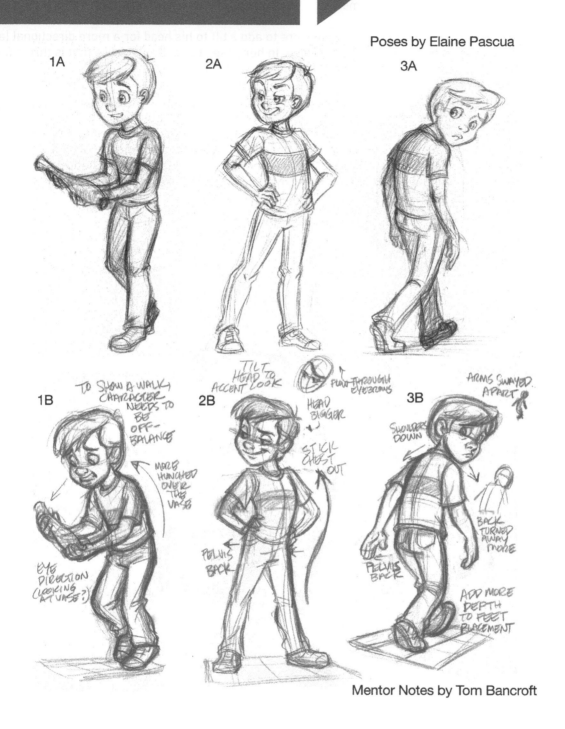

Mentor Notes by Tom Bancroft

MENTOR NOTES

Drawings 3.26a, 3.26b, and 3.26c are by Elaine Pascua. Elaine did a great job with these three poses. I think she addressed what I consider the number-one job well: clearly showing the character in the correct emotion/attitude. I think anyone could look at all three of these poses she created and know what Tommy's attitude is. My notes are to address a few things I think she can consider to make her poses even stronger. Overall, all three of her poses

feel very vertical. The core of Tommy's body is almost a straight line throughout her drawings. That was one thing I wanted to address – to make her poses a little less stiff. Specific thoughts on each pose are:

Pose #1A: I thought that if she wanted to show Tommy midstep, then he needed to have a slight lean forward to his body to show the momentum of his step. That also gives him a natural hunch over the vase he is holding, which helps to make him feel even more protective of it. I also thought that his eye direction should be toward the vase because that's the thing he is worried about in that moment.

Pose #2A: Two things I wanted to address in this pose were to add a tilt to his head for a more directional (and a bit more cocky) look and to get his chest out more in the pose. In her pose, it's really his pelvis that is thrust forward, but for that traditional, macho look, throwing his chest out and pushing his pelvis back is stronger.

Pose #3A: This was my favorite of the three of her poses because of how well it communicates the attitude of Tommy. When I wrote the description for this pose, this was the way I pictured it: Tommy turned away from the viewer with a backward, forlorn glance. My only comments to Elaine on this drawing are more concerning the mechanics of her walk stance. Like pose #1A, because he is in midstep, he needs to be leaning forward a bit. Also, the perspective of Tommy's feet didn't show much depth (to really push the idea that he is walking into the distance). Finally, his arms just looked dead at his side. Adding a slight sway to the arms helps him feel like he is in movement, but keeping the hands dangling still makes him feel sad.

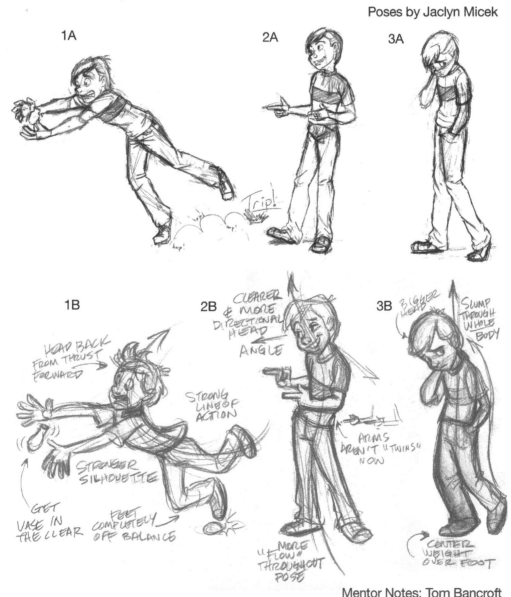

Poses by Jaclyn Micek

Mentor Notes: Tom Bancroft

MENTOR NOTES

Jaclyn did a great job with this assignment. To be honest, I really didn't have a lot to say about her poses, as they do communicate very well. That said, we all have room for improvement, and I wanted to challenge myself to see what different variations I could come up with. Like Elaine's drawings, Jaclyn's have the general feeling of being very vertical in Tommy's body core. This was one thing I wanted to address in my mentor sketches. Also, her version of Tommy is off-model, so I am striving to make it look more like the Tommy in the model sheet in my sketches. Mine are much more broad poses then hers are, which makes them different – not always better. Hopefully, she could take these suggestions and glean a few things she would add to hers and come up with the perfect "compromise" variation to these poses. These are my specific thoughts to each pose:

Pose #1A: I really like her pose on this one. The fact that she decided to show some action in this pose and tell a little story of what was happening was a nice surprise. My biggest notes here were to try and get a stronger line of action (that isn't just a straight line) to her pose and show a bit more movement. I did some of that with how I showed Tommy's hair and shirt blowing back in the opposite direction of the thrust. I pushed his head back for the same reason. Although I really like the "cupped" feel of Tommy's hands around the vase in Jaclyn's drawing, I thought I'd try the more wide-open pose for clarity. Seeing that vase flying in the air, away from the hands, is pivotal to communicating the reason for his strong reaction.

Pose #2A: This pose was good, but I felt it could be pushed more than any of the three. Again, job one for me was to get more "flow " through the body. I approached the pose with that as my first goal and worked from there. I liked the tilt of the head and tilt of the shoulders that she put into her pose, so I kept that. From there, I worked down to create more flow and offset the head tilt with Tommy's left leg (page right) sticking out, while straightening his right leg. Additionally, she lost some silhouette value and created a "twin" effect with the arms. I broke that up, which works naturally with the tilt of the shoulders that she already had.

Pose #3A: Out of Jaclyn's three poses, I think this is her strongest. My version is different, but I'm not sure it's better. The tilt of his head and the arm up, hanging from his neck while the other is in his pocket, really communicates his sad, awkward attitude well. My biggest note here, again, is that because he is midstep, there are some mechanics to that step that aren't correct. He really needs to have more weight on that foot that is in front of him. So I pushed it back a bit and bent it slightly to bear his weight more and put him slightly off balance. Doing that also gives a bit more flow through his leg and up his back to give him a stronger S curve to his stance.

EXAMPLE #2
Jaclyn Micek

CELEBRITY
ARTIST ASSIGNMENT
STEPHEN SILVER
CHARACTER DESIGNER

About Stephen

Stephen Silver was born in London, England, in 1972. Aspiring to be a professional artist his whole life and knowing drawing would be his vocation, Silver got his professional start in 1992 drawing caricatures in amusement parks. In 1993, he went on to establish his own illustration company, called Silvertoons. By 1997, Silver was hired by Warner Bros. Television Animation as a character designer and has been working in the animation industry ever since.

He has worked as character designer and supervisor for Disney Television Animation, Sony Feature Animation, and Nickelodeon Animation, designing characters such as "Kim Possible," "Danny Phantom," and Kevin Smith's animated "Clerks" series, to name a few. Silver is the author and artist of five self-published books on the art of sketching, caricature, and life drawing. In addition to working freelance full time, he also teaches

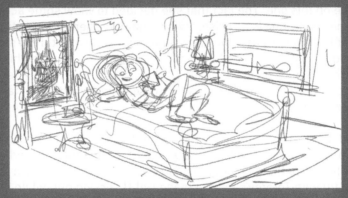

an online character design course at http://www .schoolism.com. Silver names three treasures that are key to success in life and that give him what it takes to keep on drawing: passion, desire, and determination.

His Thoughts on the Assignment

When I was first given the assignment to create Emily texting in her room on her bed and a shadowy figure in the window, I began to rough some sketches out. At that moment, I did not follow the room layout – I was just trying to plant an idea in my head. The thumbnailing process for me is extremely important, as it simply helps get the ideas out of my head onto paper. The final rough that you see here was based more on the room layout, and I wanted Emily to be in the foreground so that she became the focus. I also used the rule of thirds and placed the shadowy figure in a place that helped balance the image.

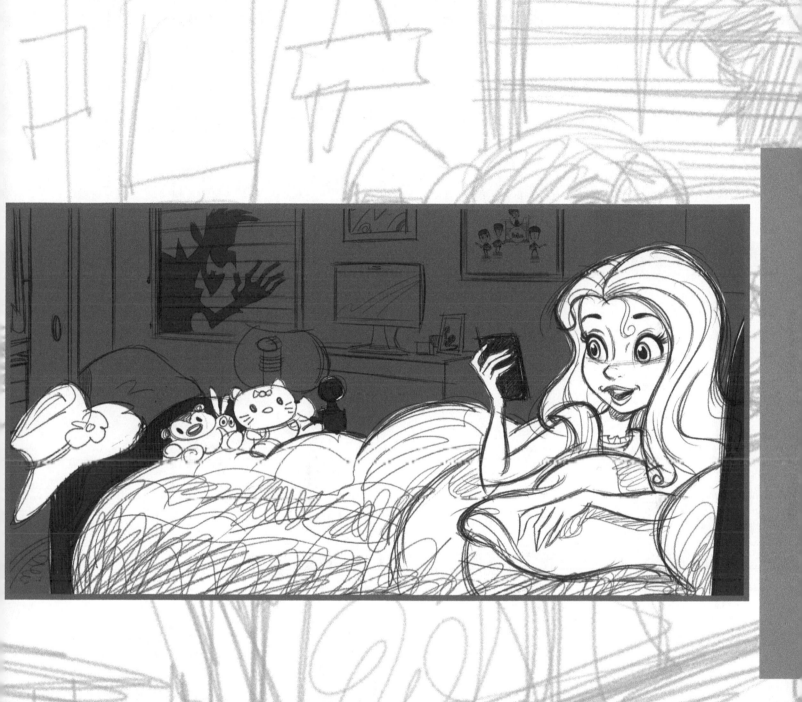

READER NOTE

Please see page 141 for the description of assignment #6. All celebrity artists have created artwork with the same guidelines given in that assignment so that we can see their equally strong but varied approaches to the same challenge.

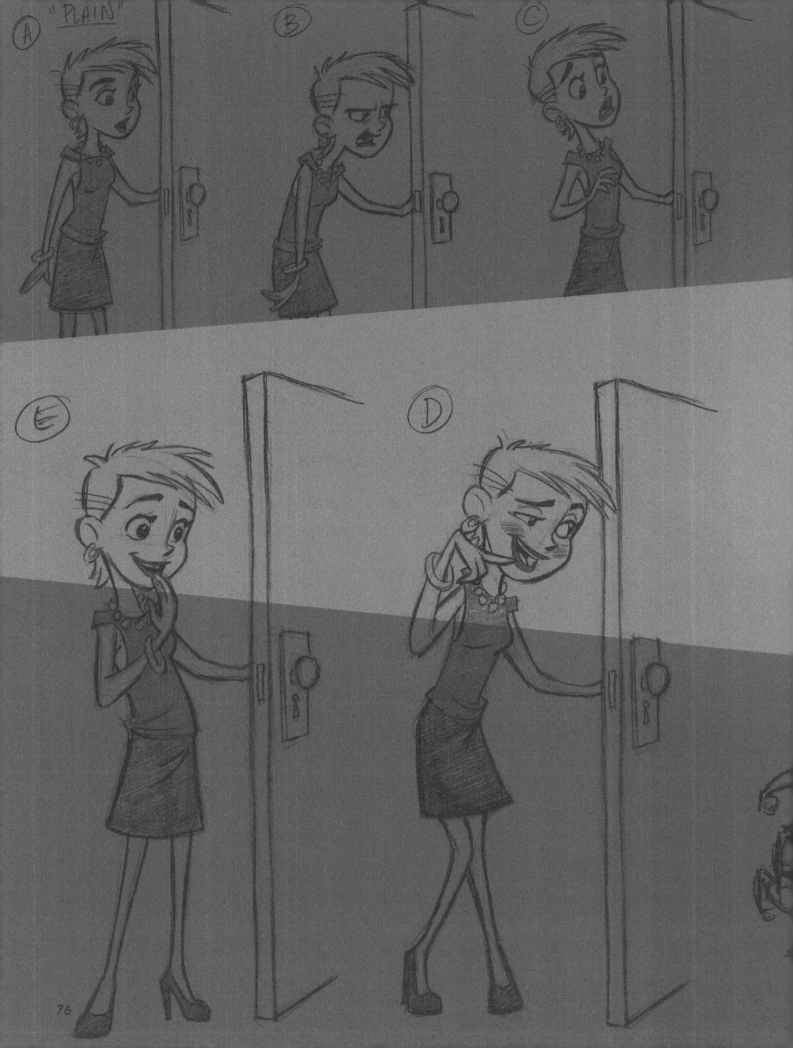

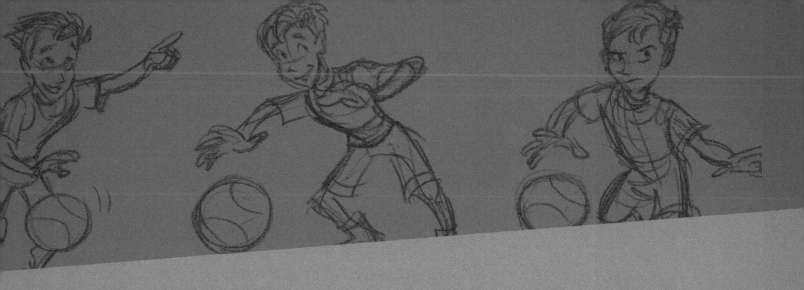

CHAPTER

ACTING

Characters Acting and Reacting the Way You Want Them to

4

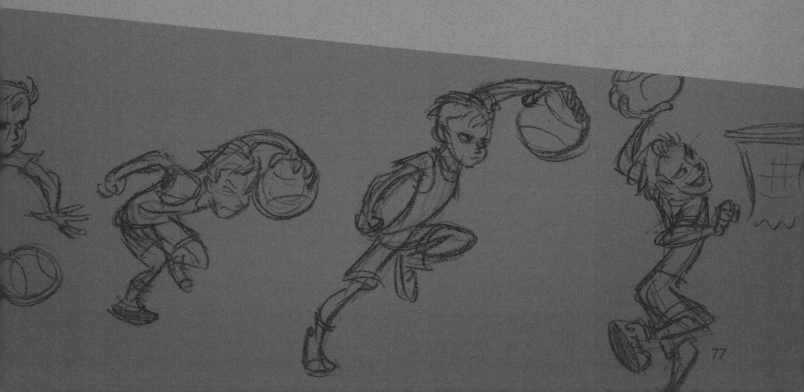

ACTING 4

After the first few chapters concentrating on generalities, we are ready to start addressing the motivations behind your character and get into the subtleties of acting via posing and expressions.

Remember, if your character is your "actor," you are its "director." He/she/it is the character who will tell the story you want told – in the way you want it told. Unlike a live action director, you have *complete* control over your actors. They won't take a break when you need them or complain that it's too hot to run up a hill or that they can't work because they don't get along with their costar. Nope: for good or bad, their performance is all on your shoulders.

As a live action film director, your best tool to figure out how to shoot a scene or what performance you want from an actor is to stick to a well-written script. For us "artistic directors," our best tool is to plan out the many different options to get the best performance. We can use an artistic tool called *thumbnails*.

Thumbnail drawings are tiny sketches (thus the name "thumbnail," because they can be as small as the size of your thumbnail) that can be done quickly to figure out a composition, pose, expression – or all of the above – before you dedicate more time to the larger, final piece of artwork.

THUMBNAILING

For many years, when I was an animator at Walt Disney Feature Animation, the great character animator Mark Henn was my mentor. Mark Henn has created and animated some of Disney's greatest characters, including: Ariel, Belle, Jasmine, Young Simba, Mulan, Tiana, and many more. Watching Mark animate was like watching a famous sculptor sculpt in slow motion – it was truly inspirational! What some people don't know about Mark is that he is also known to be the fastest animator at Disney. He could usually produce three times the amount of animation as the average Disney animator. And all of it is high-quality performance animation! Junior animators, like myself at the time, would often ask him how he did it – or, to be more specific, "What are the most important steps to creating a great animation scene?" He would always answer the question the same way: "There are three important steps: thumbnail, thumbnail, and thumbnail." Obviously, his point was there was no more important point or steps to creating a good animation scene than thumbnailing out your scene before you begin animating it.

His point applies to every artistic endeavor that is for an audience. Preplanning your drawing, animation, sequential art, or illustration composition is key to its success.

The creation of thumbnails to plan the best staging/compositions, character expressions, or poses is a tool used by the best artists in every form of media, including comic books, storyboards, video games, animation, and illustration.

Character Design

To show an example of thumbnailing, I created this preteen boy basketball player character. To thumbnail something, you need to have a reason/goal to accomplish, so I created an imaginary one: to try and create as many poses of him playing basketball as possible. I want a variety of him dribbling and a few of him taking a shot at the hoop. The next page shows a few that I was able to come up with. Which one I would use would depend on what the ultimate need for the drawing is: a video game cover, a piece of an animated scene, a spot illustration, or something else?

We will address thumbnails more later, but here are some examples of thumbnails for the boy character design from the previous page playing basketball. Some of the thumbnail poses are stand-alone poses, some are sequential. I like to create sequential actions in my thumbnails because it makes me think of the mechanics of the movement involved and helps bring some subtle extras that I may not think of if I'm just doing a still pose. Which pose or moment is more dynamic?

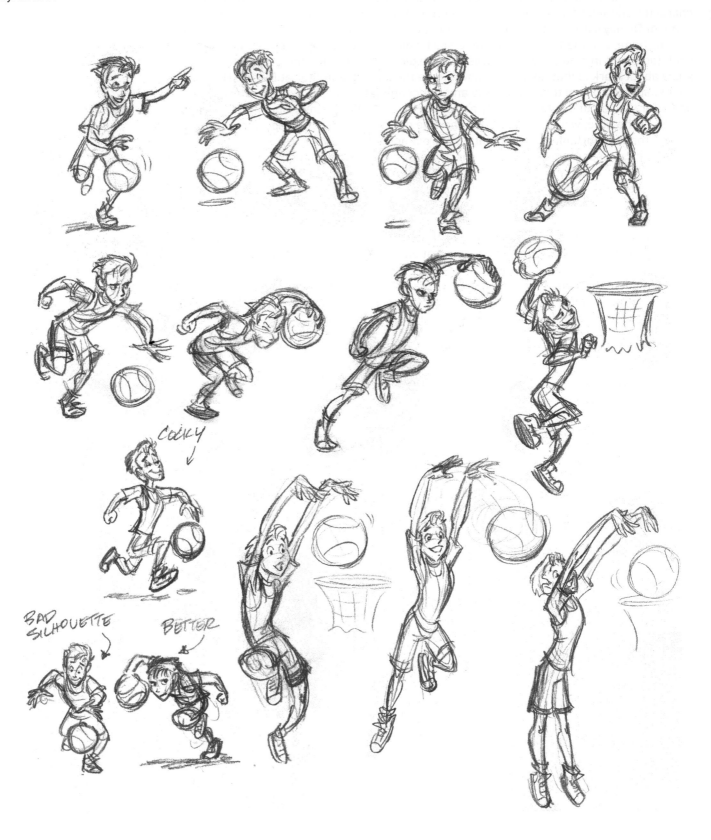

COCKY

BAD SILHOUETTE

BETTER

SUBTEXT

Any actor will tell you that the best acting is subtle. The tiny nuances in gesture, expression, or dialog communicate to an audience what the character is thinking in a big way. "Subtext" is a term that can be helpful in adding depth to your character's acting. The subtext of a character's performance is the true inner thoughts or feelings behind the words they are saying. In animation, the clues are in the character's dialog. Because the voice actors record their performance before any animation is created, they are an integral part of the character acting. A careful animator will listen to that voice actor's lines over and over again and consider not just what they are saying but also how they are saying it. Sometimes what the character is saying is the opposite of how they feel, so knowing that "story behind their words" (subtext) is important. You may have a chance to hint at the internal struggle that character is having by how you illustrate the character's pose and the expression that you create.

This challenge is even greater when the spoken word is taken away. Gone is the inflection the voice actor made while speaking that line of dialog that gave the audience a clue to the subtext in what the character is saying. All that is left is the line of dialog in written form. The job of communicating the subtle acting of what your character is thinking falls completely on you, the artist. A good example of this can be seen every day in comic books and comic strips.

As an example, imagine you are sitting down to draw the next installment of the hugely popular comic strip you and your writing partner create on a daily basis. He has given you the script for today's strip.

Imagine that your strip is about an independent young girl (let's call her "Sandy") who works at a design studio with a bunch of immature guys. One of her female coworkers has taken it upon herself to arrange a blind date for Sandy. It's with a guy that she knows outside of the office (like from the gym or something), and she thinks Sandy would like him. Who the male character is isn't revealed until the last panel. (It is someone she knows well.)

She answers the door and all she says is. "Oh . . . it's you." The subtext of what she is thinking depends on who it is at the door. Is she excited? Nervous? Depressed? Interested? Scared? Sarcastic? Following are some different poses and expressions to show the different ways to show the subtext in her feelings. This is an example in which body language speaks volumes. The first pose is how *not* to do it – just a plain pose that doesn't communicate any subtext to the audience.

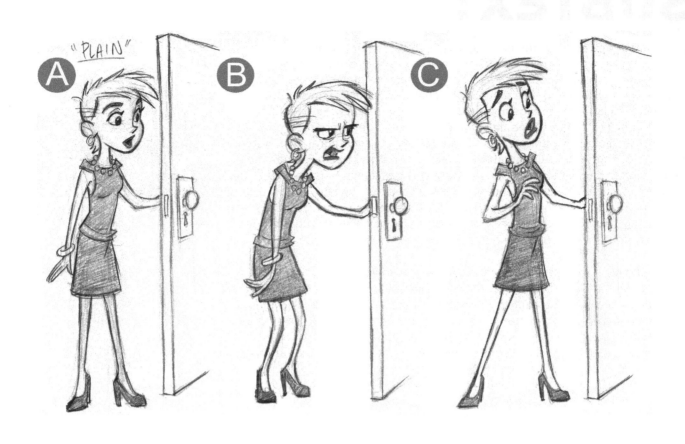

Note that you can make a word **BOLD** to add some inflection to that word. You can also change the pause between "Oh" and "it's you" by either adding a period or changing it to a comma. These subtle writing tools, along with your drawings, help sell the subtlety of a line like this.

Think of another line that can have many different meanings and create some subtle subtext poses for that line. It's a great exercise to get you to think outside of the box and really push your character's acting. Here are a few lines to try:

- "When did you say you wanted this?"
- "Can I take your order, please?"
- "Yes, he's my boyfriend of many, wonderful years."

To make this even more challenging, try using the three following characters for each situation. Each one should have an attitude depending on their "part."

3 Friends, 3 Different Shapes

I've given it a try myself here. I have put the three of them in different situations. Can you tell what the situation is and their attitudes toward it?

Also notice in these drawings that I am trying to use as many drawing tools at my disposal as I can to get these three characters to work as a group to communicate ONE idea. Note their proximity to each other, eye direction, silhouette, body posture, and expressions—all working together to make these quick sketches communicate a story/situation.

Which character recieved a good grade on his or her paper?

Which character is starting to listen?

Who is convincing who?

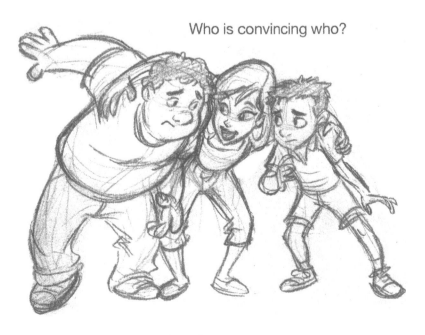

PURPOSE-DRIVEN ACTING

You have heard the line used when an actor needs to know what he or she should be doing in a certain scene, right? They look at the director and say, "What's my motivation?" As clichéd as that line has become, it is still an important concept to consider in order to give your characters life. As the director of your characters, think about what is motivating them to do/say/emote what they need to do at that moment. If you don't think it through, the audience won't understand the point of your drawing/scene/illustration/action. Let me make this clear: *everything* we do as a professional artist has a *purpose*!

Here are some examples for which I will state a goal for my character or scene, along with three different ways to accomplish that goal. One version should be the clearer way to illustrate the goal, but I will leave it to you which one works best. This is a good test for storyboard and comic book artists to practice.

Johnny is running for his life from a monster:

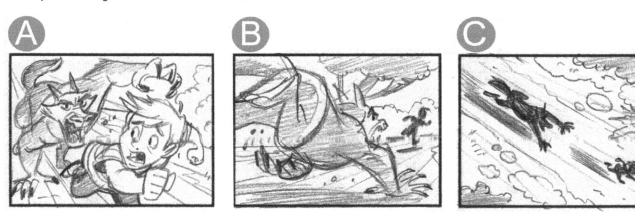

Karen sees a friend and wants to join her for lunch:

The experienced acrobat reaches for his partner midswing:

Filled with guilt, Dwayne tells Kasha the truth:

EYE DIRECTION AND PROXIMITY

Creating good, strong poses and interesting characters is important, but if your characters do not seem to interact with each other, you miss out on a key piece of storytelling. Eye direction is a key element to the illusion of character interaction. Take, for example, Figures A through C. This concept is intended to "read" as an adult reuniting with a child, a happy story moment. This works as a basic pose, but note that the pupils have been left out in Figure A. Now, in Figure B, pupils have been added, but with the eye direction not quite right. They are looking at each other but not directly into each other's eyes. In Figure C, that problem has been fixed. Even with only a millimeter's amount of movement in the pupils, there is so much more chemistry between the characters because they are looking directly *at* each other.

EYE DIRECTION A

Another common eye direction mistake to make is not having the left and right eye of a character looking in the same direction. Imagine arrows coming out of your character's eyes to help you clearly see whether the eye direction is correct between the eyes. See the following examples.

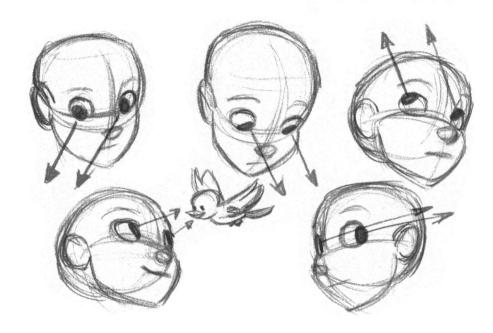

A common – and especially tricky – eye look to draw correctly is when a character's head is turned away but their pupils are looking back in the opposite direction. See Figure A for an incorrect way to draw this and a correct way using the red arrows as indicators. In most cases, the mistake is in not having the same amount of negative space (the white part of the eye around the pupil) in both eyes. The top example of Figure B shows no white negative space on the left side of the far eye, so it looks as though that pupil is looking at a more extreme angle than the front eye. Below that is a correct version with a little bit of white negative space peeking through on the left side of the far eye. Often it comes down to a pencil's width of line thickness to get the most subtle eye directions or expressions correct: sharpen your pencils and keep erasing!

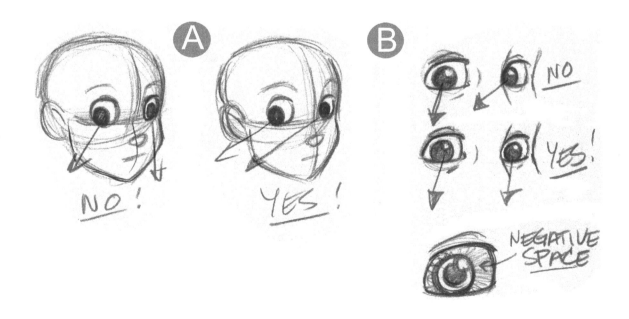

These next two examples, which I call "Young Superheroes in Love," illustrate how – even with the heads of the two characters looking straight at each other and their body language speaking very loudly that they are happy – the tiniest change in the pupils of only *one* of the characters tells a completely different story of what they are happy *about*. These two examples show how powerful the pupils are in communicating your characters' inner thoughts.

Proximity is a term I use in reference to how close an object (or *prop*, in stage terms) or person is to the character that is acting with that prop or person. Is it or are they in the correct proximity to your character to give the right feel or emotion? Proximity of your characters works hand in hand with eye direction, because how close the characters are and how much they are looking into each other's eyes says what *kind* of chemistry they have for each other. Think of a drawing of a young mom and her newborn baby. How would she hold that baby? I created four different sketches to show some ways to illustrate that pose. In Figure A, she is holding her baby far away and in a plain pose. Though the eye direction and their expressions work, their proximity to each other communicates an indifference to the baby on the part of the mom. In Figure B, the proximity between the two is cut down considerably, and now there is much more warmth felt between the two. This pose works fine, but I felt like the pose could be improved upon, so I created Figure C, which adds more emotion to the pose by adding a tilt to the mom's shoulders and head so that the her and her baby are more horizontally equal in their eye direction, which immediately brings even more warmth – especially from the baby. I could have stopped there, but I went a little further by creating Figure D. In this pose, I shifted the mom's weight back and brought the baby close to her face. Having their faces touch makes for the strongest emotional contact you can achieve. Additionally, the pose is strengthened because of some tilts to the legs and a stronger tilt and flow to the body.

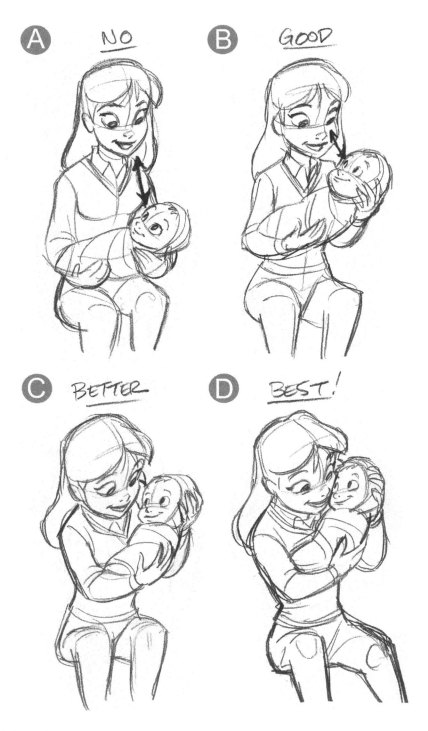

USING PHOTO REFERENCE

In the last few years, partially because of the advent of the Internet, I have discovered the importance of getting reference for whatever aspect of a design or illustration I'm working on. I never trace it, but I use it as a reference to bring some kind of extra believability to whatever I am drawing. We also need to be inspired. Sometimes a photo in a clothing catalog or magazine will give you an idea for a pose that you would not have thought of on your own. Specifically in reference to poses, I know that I can get stagnant and repetitive in my ideas. Looking at a photo reference is like a shot in the arm and gives me endless amounts of variations to draw upon. When I look at a photo reference, I ask myself these questions:

- What is *most* appealing about this pose? (Is the line of action through the pose strong, or is it the expression of the face, the folds in the clothing?)
- What can be improved upon? (Perhaps moving an arm will give better silhouette to the pose?)
- What changes do I need to make to get my character into that pose? (If the reference is of an adult, but I'm drawing a preteen; or it might even be a photo of a human but I am drawing an animal into that pose!)

I found a great photograph of a little girl whispering into a boy's ear and felt the urge to draw it. I did not want to copy it, but like I mentioned, I really wanted to take from it what was cute and appealing and make my own characters doing that action. I did not change the characters too much, but I did make them a little older. The other change I made was to have the little boy's pupils looking up, so it seems he's thinking about what she's saying a bit more. Here's the result:

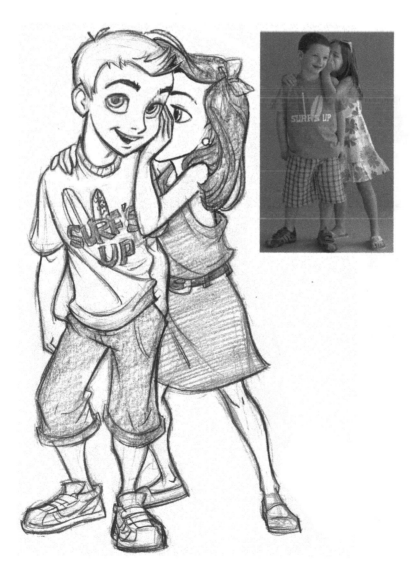

Next, I wanted to give that challenge to others and see what they came up with. I also wanted to create my version of the same assignment for comparison. I created an original character that I call "Ellie the Angel," then drew up some orthographic sheets for others to see her from different angles. I was pleasantly surprised to have a CG modeler in Paskistan named Usman Hayat offer to create a dimensional figure of Ellie, which is also here for your reference. Additionally, I created some varied facial expressions for Ellie as well as placing her in various poses. These steps helped me explore her design and see errors that I could tweak along the way.

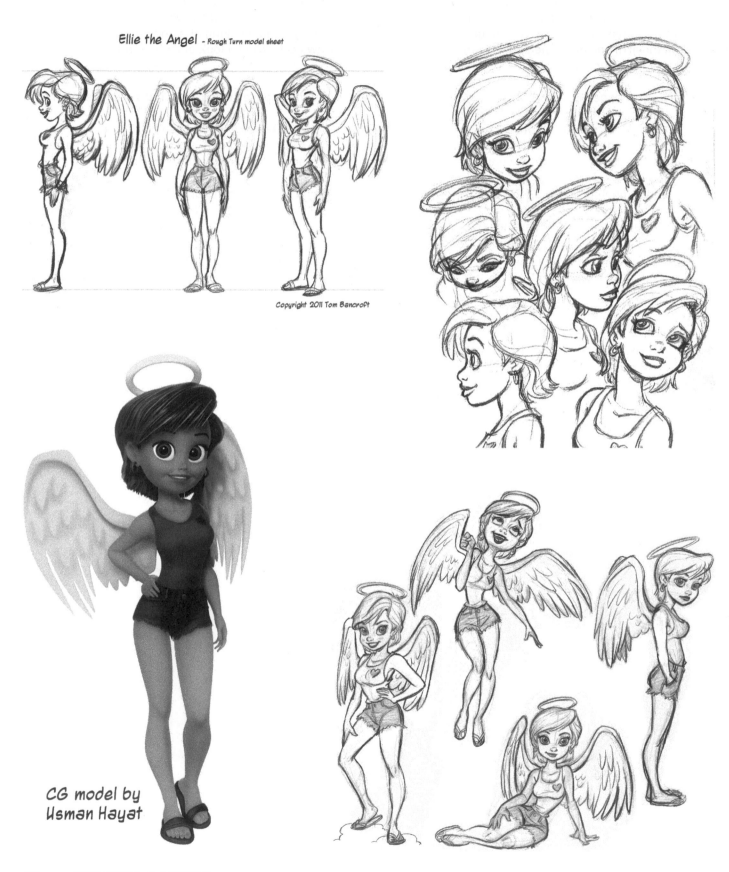

Ellie the Angel - Rough Turn model sheet

Copyright 2011 Tom Bancroft

CG model by
Usman Hayat

Along with the orthographic sheet, these three pages should be plenty of reference for the art students to create their own poses of Ellie using some photo reference as a guide. For the photo reference, I asked my oldest daughter, Lexie, if she would pose as Ellie. Lexie doesn't look that much like Ellie, but I really don't want her to.

The challenge here is for the artists to interpret the photo reference (Lexie's poses) and make them into Ellie the Angel. That will mean drastically changing proportions and simplifying details considerably while still trying to retain the essence and charm in the pose. Each of the three artists were given one of the photos, and all of them got Ellie the Angel reference. This is what they came up with:

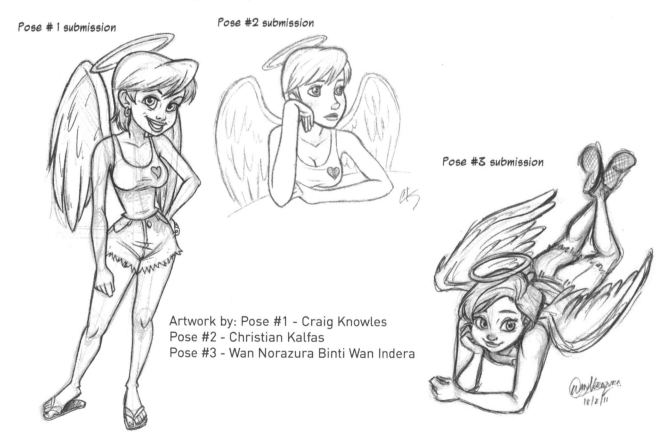

Pose # 1 submission

Pose # 2 submission

Pose #3 submission

Artwork by: Pose #1 - Craig Knowles
Pose #2 - Christian Kalfas
Pose #3 - Wan Norazura Binti Wan Indera

I really like what they did. You can always tell when an artist is having fun with a drawing, and I think each of these artists enjoyed the project. I do see some areas for improvement, so I created my own Ellie versions of these poses to point out some of those suggestions.

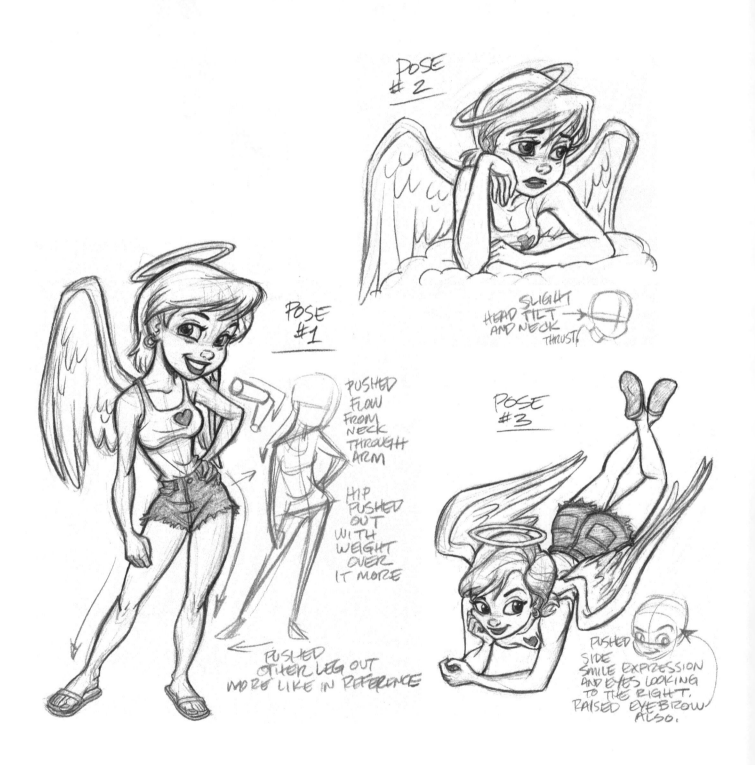

POSE #2

SLIGHT HEAD TILT AND NECK THRUST

POSE #1

PUSHED FLOW FROM NECK THROUGH ARM

HIP PUSHED OUT WITH WEIGHT OVER IT MORE

PUSHED OTHER LEG OUT MORE LIKE IN REFERENCE

POSE #3

PUSHED SIDE SMILE EXPRESSION AND EYES LOOKING TO THE RIGHT. RAISED EYEBROW ALSO.

MENTOR NOTES
FOR ELLIE PHOTO REFERENCE POSES

Pose #1 is drawn by Craig Knowles. He is obviously a talented draftsman. You can see his drawing knowledge in the dimension and solidity of his Ellie drawing. He also did a great job making it look like Ellie. The thing I missed in Craig's drawing was what I feel is the essence of this particular pose: to me, the essence of this pose is what I notice first – the strong hip thrust and head tilt with the cute look at the viewer. Craig got the look with the eyes and head tilt, but missed the strength and weight shown in the hips and legs that is in the photo reference of Lexie. I usually do not draw exactly what is in the photo reference. I look for ways to push expressions and poses whenever possible. In my sketch, note that I pushed Ellie's left shoulder down a bit lower than it was in the photo. I felt like this would give a more dynamic feel to the pose and create a nice flow from the neck down to the end of the arm. I am still not sure showing the far wing is a good idea. It hurts the silhouette of the pose. I did move it more to the left, but it is still obstructing the cheek and bent arm a bit more than I would like.

Pose #2 is drawn by Christian Kalfas. Christian is also a good draftsman and did a good job with this pose. My suggestions center around Ellie's head. In the photo of Lexie, she has a sad look on her face – kind of a defeated, "I give up" kind of expression. That expression is missing in Christian's sketch. As with Pose #1, though, I went a little further with it in my sketch suggestion. Lexie has a slight tilt to her head, which I included in my sketch, but I pushed the heavy-lidded feel to the eyes. I also pushed the feel of her resting her head on her hand by squashing the cheek a bit, with the cheek even compressing into the eye slightly. Finally, to push the sadness a bit more, even her wings and halo are sagging. Adding a cloud as the base for Ellie to lean on seemed like a fun addition also.

Pose #3 is drawn by Wan Norazura Binti Wan Indera. Honestly, I cannot say enough good things about Wan Norazura's drawing of the reclining Ellie pose. This was the toughest of the three poses (especially because of the angle of the picture), but Wan Norazura made it look easy. I did a version myself, but I cannot say if I improved it much. What I did want to point out that I think could strengthen Wan Norazura's pose is the slightly thinner torso I gave Ellie for two reasons: (1) it fits her "model" more, as you can see if you look at the model sheets and (2) it opens up the space between the tip of the halo, the far wing, and her bottom. That little change improves the silhouette quite a bit. I did add a stronger feel of compression (or squash) to her face, which I think helps also. Finally, I really liked the almost sneaky expression on Lexie's face in the photo reference. I changed two things to try to achieve that: (1) I lifted the eyebrows and (2) I made the pupils more directly reflect the pupils' direction to the right. In the end, I think I like Wan Norazura's expression to the face more than mine, but would love to see hers with the eyebrow change and face squash I added to mine. That would be the best of both, I think.

Great work by all three artists!

CHARACTERS LISTENING
TO EACH OTHER

In traditional animation (as well as in computer animation) for feature films, you are "cast" by the directors on which characters or scenes you get, depending on what you are most proficient at in the area of animation acting. I have worked on a variety of different characters, from wildly cartoony (Roger Rabbit) to loudmouth (Mushu) to subtle acting (Young Simba) to *very* subtle acting (Pocahontas *and* her hair). Because you don't always know what you will be working on from day to day or scene to scene, the best animators are flexible in their acting abilities. All that said, one of the toughest things you can get placed on your desk is a scene were a character is *listening* to another character. Sounds easy, huh? Well, it is easy – easy to do badly. Easy to make look stiff and robotic! But very hard to make look casual or correct for the emotions needed for that scene. Think about it: all the things we do as actors with a pencil or cursor, we can't do: the flinging around of the hands; the mad gesturing of the fingers; the sassy head thrusts; and the cocky head tilts with the raised eyebrow addition! All gone. Any of those things looks unnatural when your character is supposed to be engrossed in what another character is telling him or her. Maybe a slow head nod? Perhaps. A subtle tilt of the head, or a slight smile? Might work. It really depends upon what the other character is saying in context of the story. And that's the main point here: never forget what your character is supposed to be thinking about what is being told to him or her. That has *everything* to do with how he or she listens and reacts. Keeping that in mind, whenever possible, I try and keep my listening character slightly occupied. Think about how you listen when your spouse or best friend is telling you something. In my case, my wife comes home from work (or I come home to her) and we do a quick recap of the day. Meanwhile, our kids are running up asking questions, telling stories, and generally cutting us off. Also, my wife may be unloading the dishwasher as we are talking. Me? I may be going through the mail that came that day and that is sitting on the counter in front of me as I talk. *Lots* of activity in a short conversation. That's *life*.

When I was at Disney Animation Studios, the old animators had a word for this: *business*. Giving your character some "business" in a scene meant giving a character something *to do* while they say their lines – not just stand in one spot. If it was something that could be used as a tool to symbolically make their point, all the better. You can go too far and make your character's business a distraction, but a well-thought-out small action is usually a plus in a scene.

Early on in the production of the film *Mulan*, when I was just starting to animate the little dragon character, "Mushu," I had a challenge hit my desk. It was the scene where Mushu was hiding behind Mulan's neck scarf, hiding from the people in the camp, while having a conversation with her about how to "be a man." In this scene, he had just made a joke, so he starts laughing and says, "Hee, hee, I kill myself"! In the storyboards, he is in one position, behind her head laughing. I started thinking about the environment around him and if there were an opportunity to create some business for him. I listened to Eddie Murphy's (the voice actor of Mushu) voice recording of the line, and he added a little bit of a whimper sound to the line "I kill myself." That was it! He's laughing so hard, he's wiping tears away from his eyes! It gave me a visual to animate to show how much he loves his own humor. That thought unlocked another: even with this limited environment – the back of Mulan's head – I had something I could use that was within Mushu's reach – her scarf that he is hiding in. I animated the scene so that he is leaning forward at the beginning of the scene, laughing, then falls back, grabbing a section of Mulan's scarf as he leans back to say, "I kill myself." He wipes his eyes as he says the line. It all happens quickly, but the end result is a slightly more humorous scene that still feels natural. There was a risk of overcomplicating the scene, but I was careful not to overdo the general flow of the action – and the gamble paid off!

As an example of this, here is a simple situation told in two different ways. In the first version, it is very straightforward. It works, but is it as visually entertaining as it can be? In the second scenario, (steps 1- 3), he may be doing something else, but you can still tell he is considering what is being said. Especially in how he responds, the change in emotion – that is accented by his action – is more powerful.

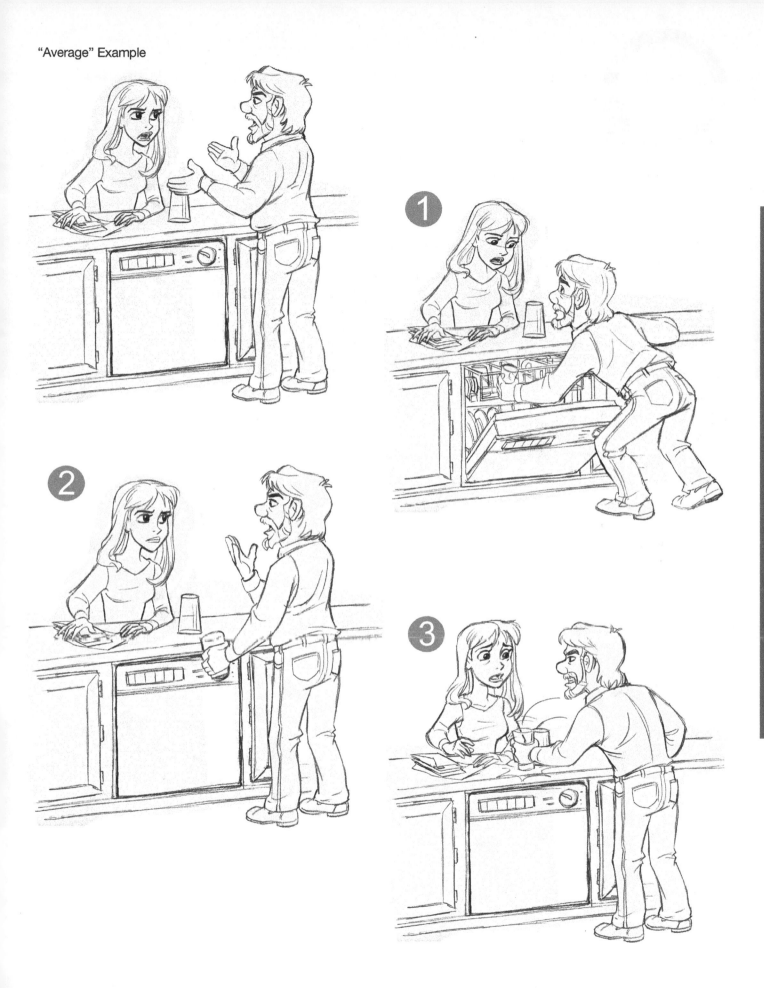

"Average" Example

①

②

③

 # ASSIGNMENT #4

Using the "Tommy" model sheet from page 70, once again, create a series of at least six to eight different thumbnail sketches to describe this action: Tommy is sitting in a chair eating a bowl of cereal (facing three-quarter front, page right). He hears something behind him (page left), reacts, jumps out of his chair, and runs off screen in that direction. Think of these as rough animation poses. They should relate to each other. Strive for the clearest pose to express each step of the action Tommy is going through. Think about this happening to you. Act it out in a mirror if you want. What are the key poses you go through, and how does each pose set up the next pose? Create multiple sketches of different poses to explore multiple possibilities.

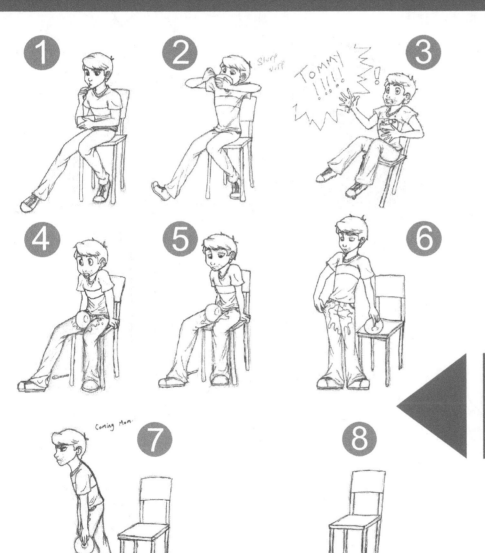

EXAMPLE #1:
Alexandria Monik

MENTOR NOTES

First off, I want to be clear that there are many, many different ways to thumbnail out any action. Thousands, in fact. For each of the sketch suggestions I have given as my mentor notes for these two talented artists, I could have made so many subtle changes and variations – with each change creating a domino effect of changes to each subsequent thumbnail pose. Because of this, the way I approached reviewing these thumbnail submissions was (1) to try to work with the idea the artist has come up with (hopefully not losing the story or emotions they are trying to show) and (2) going with the first ideas I see that will strengthen what the artist has created.

Alexandria did a great job with this Tommy story and told it in a very funny way. The drawings are very clearly drawn, but the poses are a bit stiff and not quite as clearly silhouetted as they could be. That is the big thrust for my sketch changes in drawings #1 through #3: clarity. I turned Tommy in pose #1 to the (page) left so that the arms are more clear of each other; additionally, I have him more slumped over so that when he goes into pose #2, there is a stronger change in his body shape. In pose #3, the important thing I am trying to show is getting his head out (free of his shoulders) and – most of all – getting the cereal bowl flying in front of him where it can be seen clearly by the audience. In poses #4 and #5, I thought it was stronger to the story to save the gag reveal for pose #6 by keeping the bowl turned over on him. A slight head tilt on pose #5 also helps to spotlight the eye direction change. In pose #6 – the big reveal – tilting the torso and opening the arms and legs up more gives the reveal of his pants mess a bit more punch. Alexandria already had the ending working well in pose #7 – I just hunched Tommy over a bit more so he seemed even more disturbed. Finally, I added a milk spill trail to pose #8 so that there is a little bit of a "period" at the end of this scene.

MENTOR SKETCHES for
Example #1 by Tom Bancroft

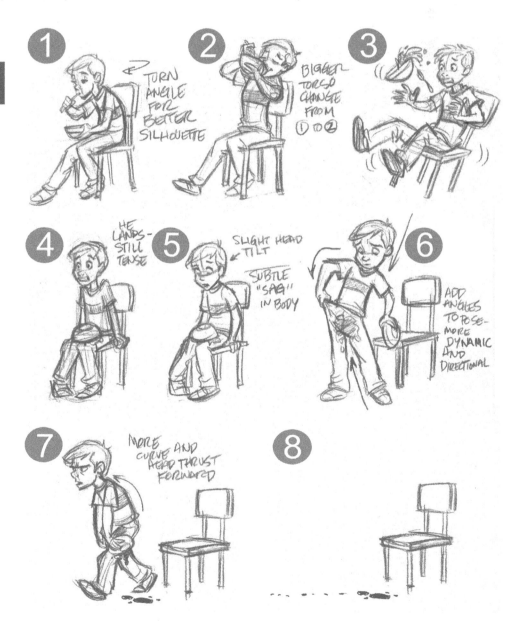

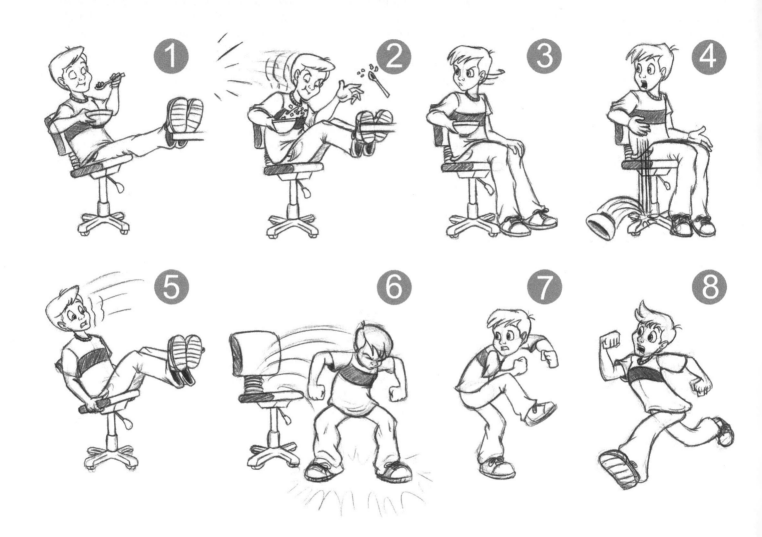

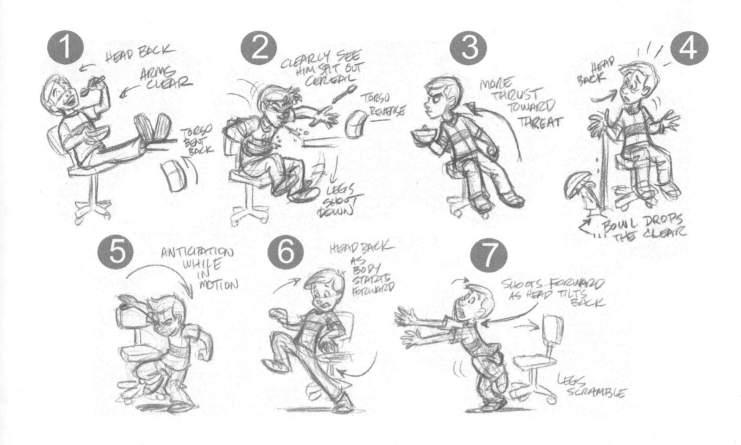

MENTOR NOTES

Brad, like Alexandria, created clearly drawn poses of Tommy, and it was very easy for me to see what was happening – except for the cereal bowl drop in poses #3 and #4. By having Tommy turn with his arm holding the bowl out in front of him, we can clearly see the bowl fall when he straightens from shock of whatever he sees. The second challenge that I saw in Brad's poses is a bigger animation principle that is a common mistake made by beginning animators. I have done it – we all have done it. And that problem is having too many "anticipations" for an action. One of the basic principles of animation is that for every action – say, an arm reaching forward to pick up a soda can – you must anticipate that action by moving in the opposite direction first. If you look at Brad's poses #5, #6, and #7, he has three anticipation drawings in a row. After Tommy's reaction in pose #4, Brad has him fling his body back, throwing his legs in the air (in pose #5), then slamming them down on the floor and crunching down (pose #6), then (pose #7) going into a big, Hanna Barbera–style anticipation (not that there's anything wrong with that) to his run off screen in pose #8. You just don't need all those poses and stops to the action. So I had him "move through" the action a bit more by combining a few actions to overlap the movement a bit more. In my pose #5, he is jumping off the chair, landing in a squash, but his leg is still up, so that he feels like he is still midmovement. Next, I had him start to move forward in pose #6 but had his head go back to offset his feet moving forward. In pose #7, I threw his arms forward to accent his frantic feeling toward whatever is off screen. I see this as a cartoon scramble of his feet sliding a bit, then his body catches up. Hilarity ensues.

Thanks to Brad and Alexandria for their nice work on a challenging assignment!

CELEBRITY ARTIST ASSIGNMENT
TERRY DODSON
COMIC BOOK ARTIST

About Terry

Oregon-based Terry Dodson has been a comic book professional since 1993. He has worked on such books and characters as Harley Quinn, Spider-Man, Star Wars, Superman, Wonder Woman, and the X-Men, and he is currently drawing the Defenders for Marvel Comics. Terry is now working in the European comics market as well, with the graphic novel series *Songes* for French publisher Les Humanoides Associes. This work has enabled him to do full-color art for the first time. Terry has also worked in toy and statue design, animation, and video games and has had a gallery exhibition featuring his paintings. He remains a popular artist in the industry – a status he attributes in large part to the contributions of his wife, Rachel, who adds her talented inking to his work. His website is http://www.terrydodsonart.com.

His Thoughts on the Assignment

The first thing I did was to find a composition that would include all the necessary information/objects of the setting. Next I figured out how to tell the story in the proposed composition.

I decided to use the main figure, Emma, as the focal piece of the art and to use the Looming Shadow, as the secondary focus. This was easily done by making Emma the big element in the art and having her be the "active" moving object in the composition. I used a couple of things to bring the secondary element, the Looming Shadow, into focus – I used the main vanishing point of perspective on the Looming Shadow to lead the viewer's eye to it, Emma's back foot pointing at the Looming Shadow, the bean bag on the ground leaning toward the Looming Shadow, and finally the teddy bear looking at the Looming Shadow.

To add depth and interest, I used overlapping shapes in the set perspective – teddy bear/pillow, then Emma herself (hands in front of head, in front of shoulders, in front of legs, one leg crossed in front of the other), then the bed, chair, desk, monitor, wall, window/frame, shadow, brush, and sky.

Finally, for realism and atmosphere, I like to include little details – the stuffed bear, Emma's tongue out to emphasize her absolute absorption with her texting, the time on the clock.

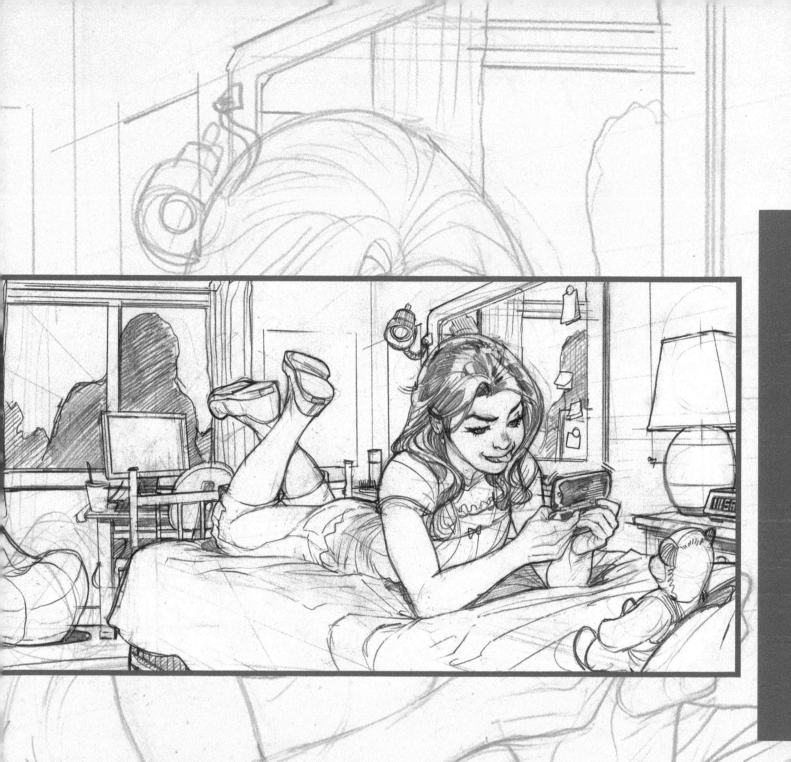

READER NOTE

Please see page 141 for the description of assignment #6. All celebrity artists have created artwork with the same guidelines given in that assignment so that we can see their equally strong but varied approaches to the same challenge.

CHAPTER 5

STAGING YOUR SCENE
Using the Elements
of Your Scene to
Create a Composition

STAGING YOUR SCENE 5

To be able to tell a story with your character, he or she has to live in an environment of some kind. It may be extremely simple or complex, but without a feeling of "place," your audience can't establish where your character is – and where he or she is going. Does the character come first, with the background designed around them or vice versa? I like to think of the entire scene I am trying to design, with the character(s) as just one of the elements of that design: the most important element, but part of the whole.

First, a few definitions may be needed. There are two words that I will use often in this chapter: staging and composition. These two words are sometimes used synonymously, but there is a difference. In reference to how we will use it in this book, *composition* refers to the choices involved in designing a scene or picture within a field (or box). *Staging* refers to how the character is used within the environment to create the composition that best tells a story. So staging is an element or a tool used to create a composition. Think of staging your character like a stage in a play that has been set already; now you must place your actors and props into that setting to tell the story in the clearest way possible.

As usual, let's start with the basics and work up from there – shapes only. Our goal will be to fill a box with only five elements. We will be challenged to create a scene of some kind between the two "characters": the black rectangle and the grey oval. The other three elements – the straight line, the wavy line, and the triangle – will be used as our environment.

Here's one way to do it:

In Figure A, the straight line becomes the horizon line and everything sits on it. The wavy line becomes hill shapes, and the triangles stand in for trees. This makes for a flat scene, but it does communicate an idea in a clear way.

One easy artistic principle to apply that will make a big difference in how you obtain more depth is *overlap*. By moving the rectangle and oval "characters" down and larger, they will cover up the horizontal "horizon" line. This overlap, as shown in Figure B, of the shapes "over" that line will graphically make them feel like they are in front of that line. Making them slightly bigger pushes that concept even more, giving this layout an even greater feeling of depth.

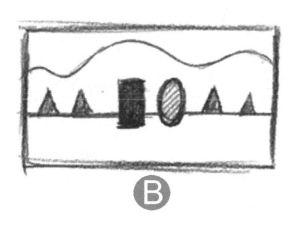

And, finally, in Figure C, I have applied that same principle of overlap to even more shapes to create multiple fields of depth. This design also uses shape size variation to push the feel of depth even further.

With only those shapes, how many different layouts can we create? It's almost endless. It is a bit of a challenge telling a story with just these basic shapes and the simple concept of "depth," but let's try a few. The goal is to try to tell a story with our simple shape characters. Are they friends? Is one chasing the other one? Is one a good guy and the other a bad guy?

These are only five of many, many solutions to this design challenge. Can you think of more? Try a few. It is like Sudoku for artists!

As you can see from the previous example, every illustration is a design with shapes. When you break things down to simple shapes, you will be able to clearly see the things that are working – or not working – in your compositions. Best of all, you find these things out with less time put into the drawing.

THE RULE OF THIRDS

When we first start taking photographs, such as those of your friends or family, the basic rule we naturally follow is to put the main subject in the middle of the frame. *Symmetry* (defined as exact correspondence of form and constituent configuration on opposite sides of a dividing line or plane or about a center or an axis) is our natural default when we are first approaching the subject of filling a space or shape. We naturally want to place things in the middle of the square, or if we have two things, space them evenly apart within that shape (Figure A). This is *not* what is most pleasing to our eye, though. In general, the artistic, creative side of us wants to see *asymmetry* in the world around us, especially within a shape we are adding elements to – like a blank canvas, for example. One of the most basic design principles that we can apply to our compositions and how we approach them is *the rule of thirds*. The basic principle behind the rule of thirds is to imagine breaking an image down into thirds (both horizontally and vertically) so that you have nine parts. The theory is that if you place points of interest in the intersections or along the lines, your composition becomes more balanced and will enable a viewer of the image to interact with it more naturally (Figure B). Studies have shown that when viewing images, people's eyes usually go to one of the intersection points most naturally rather than the center of the shot. Using the rule of thirds works with this natural way of viewing an image rather than working against it.

Keep in mind that you don't need to get out a ruler and make perfect, measured lines on your drawings. Use this as a rule as something you visualize on your drawings as you are creating your rough concepts.

In learning how to use the rule of thirds (and then to break it), the most important questions to be asking of yourself are:

1. What are the points of interest in this shot?
2. Where am I intentionally placing them?

Also, remember that the rule of thirds concept is a design principle that applies to all elements of your illustration, including your character's posing. Note that in pose A I have placed a "thirds" guide around the two poses. I created pose B with the intent to break up the placement of the knees, arms, feet, and head in order to make a more interesting pose that is not so symmetrical and evenly spaced. You will get more interesting poses by considering the rule of thirds lesson.

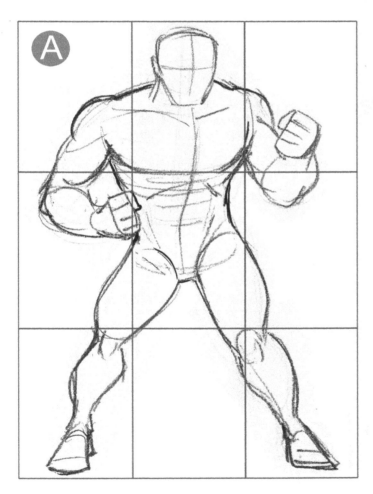
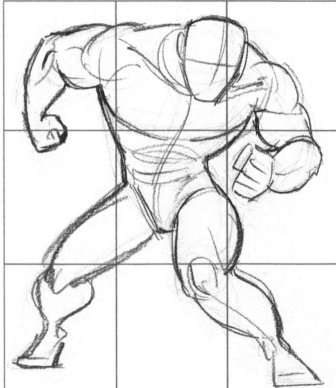

CHOOSING YOUR SHOT

To use the live action film analogy again, every composition we put together is like a scene that a cinematographer would shoot for a film. In every illustration, storyboard, comic book, comic strip, or animation that we create, we are the artist, director (for that moment at least), and cinematographer all rolled up in one. This is the viewpoint I take when I start a composition. As I start my thumbnail process, I start imagining the environment that my character and situation is taking place in. Depending on what story point I am trying to achieve at that moment, I start imagining where I will "place my camera." This is a great way to figure out interesting "shots" to view your scene. Is my "camera" at a low angle, looking up at the character/subject? Am I viewing the scene from high in the air? What angle will work best for the story I am trying to tell?

Following are some of the most common staging "camera" shots. These are important to know and use because they are used in every film, TV show, comic book, video game, and more.

First, here is a map of the environment that I will be "shooting" so that you have some reference of where I am placing the imaginary camera. Actually sketching out a map of an environment is really helpful so that you know what elements (buildings, signs, mountains, trees, etc.) are around your character. You will get a better feeling of consistency from panel to panel this way. Also, you won't have as much guesswork as to what you should draw as a background in each shot.

Extreme Wide Shot (EWS) – Also called an *establishing shot.* A far-off shot that showcases an entire location. Usually used at the beginning of a sequence to establish a new location – how far one building is from another and the like.

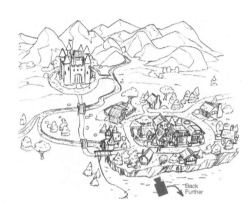

Wide Shot (WS) – A shot that is within a location but still shows a good amount of it. A good shot to establish where your characters are within a location. This example is out far, but this shot could have the characters filling the frame and still be considered a wide shot.

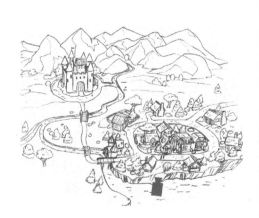

Medium Shot (MS) – A shot that features your characters from the waist up.

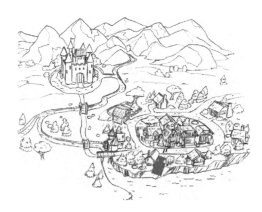

Close-Up Shot (CU) – A shot that features your character from the shoulders up or some other prop/object in which it is the focus of most of the framing.

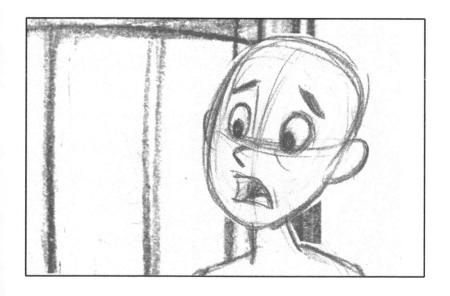

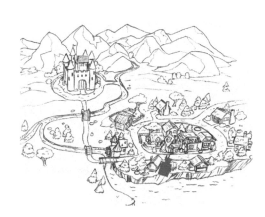

Extreme Close-Up Shot (ECU) – Usually a shot that is within the face, like focusing on just the eyes of a character. Can also be a very tight shot of an object/prop to spotlight a section of that object/prop (like the bristles of a toothbrush in a commercial).

The diagram below is a simple "cheat-sheet" guide so you can see how these shots are used in relation to a character in fielding.

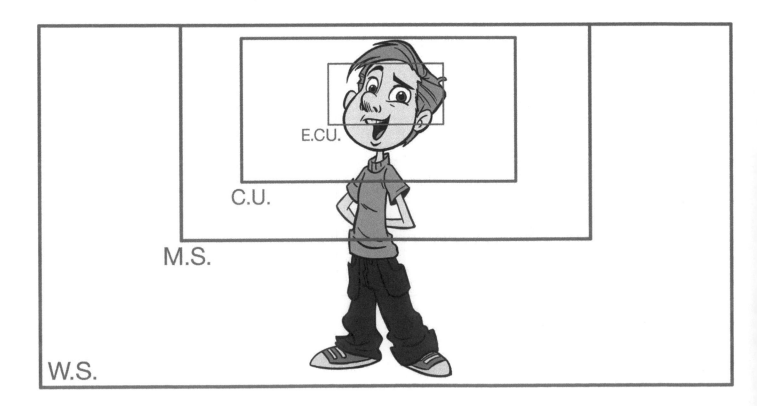

Subset camera shots of these basic shots are even more specific to where your "camera" is placed or how it is being used. Most all of these terms come from the live action film industry but have been made a part of the animation, comic book, video game, and even illustration industries as terminology to help describe a more cinematic look that is the goal of a composition.

Here are a few terms that are important to know:

UPSHOT (or "worm's-eye" view) –

The "camera" is low but angled up to view a subject.

DOWNSHOT (or "bird's-eye" view) –

The "camera" is high but angled down.

POINT-OF-VIEW SHOT (POV) –

A shot that is supposed to seem as though we are looking through the character's eyes at what they see.

OVER-The-SHOULDER Shot (OTS) –

This shot is just like it sounds: the camera is over the shoulder of a foreground character, viewing something in the near or far distance. Used to show the characters' point of view (though not as directly as a POV shot) of another character or scene.

PAN SHOT (sometimes called a "dolly" shot) –

The camera moves left, right, up, or down in a flat, perpendicular way. The camera does not tilt its axis but "slides" across a scene, usually to follow a character or action happening.

TRUCK IN or TRUCK OUT –

This shot is usually confused with "zoom in and zoom out" (below), but to "truck" in your "camera" means you are physically moving the camera closer to a subject, which will act as a zoom *except* that the focus will not change.

ZOOM IN and ZOOM OUT –

Keeping the camera stationary, but shifting the lens's focus to a closer or farther away point. Although, in live action film, the "truck" and "zoom" definitions achieve different effects, in the context of drawing they are pretty much identical.

TILT SHOT –

Similar to a pan except that the camera is stationary. This shot will create a perspective change as you tilt the camera up or down toward the subject.

Many times, these camera shots can be combined to create more specific or complex shots. This cheat sheet should give you some basic knowledge of the different types of shots you can use for staging your characters in your compositions. In the next chapter, we'll look at how you can use them in a variety of formats for various forms of media.

POINT OF VIEW

Concentrate on the "why" of staging your character in the composition you are designing. This way of looking at your scene is best summed up as *point of view*.

The two specific points of view that I would like us to concentrate on are character-driven and story-driven. The goal of establishing the main point of the scene is to discover the strongest staging of your character that will work best for that shot. If a scene is there to tell a story point, that is a story-driven point of view; if it is there to further what the character is doing or thinking, then it is a character-driven point of view. Many times, a scene has both points of view. This type of scene can be extra tricky, so make sure you stage the scene well. Here are some simple situations (which could come from a film or a comic book script) to illustrate different points of view. Note the ways to show or shift what the focus is on through staging.

Trevor goes for it in the front seat of Paula's car. Paula is shocked and starts to lift the bottle:

Character-driven

Story-driven

Character-driven / Story-driven

Jennifer smiles at him warmly:

Character-driven

Character-driven / Story-driven

This phrase is really just a character-driven story point. One could say that the part of the phrase, "at him," is alluding to a story point, so I showed a view that included him also.

Richie nervously reaches for the golden goblet that is about to fall off the shaking table:

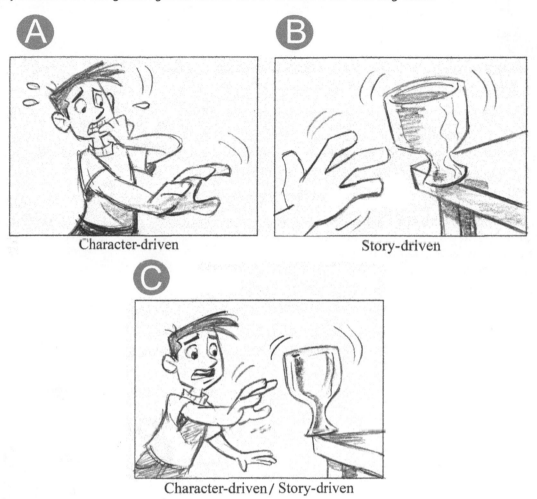

He lifts the box up for all to see – it's Fruity Crispy Flakes cereal!:

Again, some would say that this is only a story-driven scenario, but the "he" at the beginning makes me think that we could create a version that showcases both the character and the cereal.

ASSIGNMENT #5

Create two panels to illustrate the same moment or event, but from two different angles and/or story perspectives. The first will spotlight the character's reaction (a *character-driven* point of view) and the other will illustrate the story point being made (a *story-driven* point of view).

Use a 5×7-inch rectangle format for both panels and place them together on the same image or file, with each labeled for that point of view you've illustrated. Here is an example that you can photocopy:

Use this situation and character designs: "Megan and Adam are running through the forest singing to each other. They are starting to like each other. Neither of them notices the pit that Adam is about to fall into."

1

Character-driven

2

Story-driven

Megan and Adam

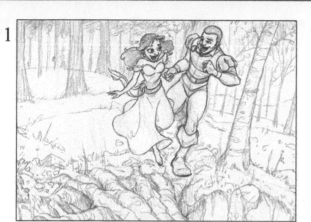

1

Character-driven

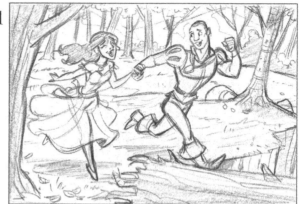

1

Character-driven

2

Story-driven

by Andrew Chandler

2

Story-driven

by Tom Bancroft

MENTOR NOTES

Artist Andrew Chandler created this example (on the left), and I have to say that he did a great job. He thought through this assignment and came up with *two distinct solutions* – which was the point of this assignment. I am addressing notes that I think he can consider for the future to strengthen his work.

Panel #1 – character-driven point of view. A couple issues that stand out are that his layout is very symmetrical and that the idea of Adam about to fall into the hole isn't as clear as it could be. Because this is the character-driven perspective panel, I expect that the characters singing to each other, would be the main focus but I do want to see a hint of the impending fall. Because of that, I created a layout in my version of panel #1 that places the characters in positions that (1) are more asymmetrical (even the angle of the fallen tree no longer is in the middle of the shot) and (2) show Adam clearly (part of his foot is behind the log) about to make a mistake – with a bit more of an indication of a trench to the right, also.

Panel #2 – story-driven point of view. This works so well that I didn't change his angle at all. My only artistic suggestions here concerned clarifying the characters' interaction and the fact that Adam is about to fall into a huge trench. In my sketch I made sure to place him over to the right more with Megan more to the left, aligned with the fallen tree. Finally, I designed the background to have a larger clearing in the section where are heroes are in order to make them stand out more. I did place them in the middle of the panel (as did Andrew), because it seemed like an acceptable situation to break the rule of thirds for reasons of clarity.

CELEBRITY
ARTIST ASSIGNMENT
BRIAN AJHAR
ILLUSTRATOR/CHARACTER DESIGNER

About Brian

Brian Ajhar's professional career as an artist has spanned three decades. His extensive and diverse client list includes magazines, newspapers, advertising agencies, corporate clients, and book publishers. His illustrated children's books have been published worldwide in a multitude of languages and have appeared on the *New York Times* bestseller list. Brian is currently focusing his attention on character design and visual development for feature animation.

More about Brian and his work can be found on his website, http://www.ajhar .com.

His Thoughts on the Assignment

The first thing I did was study the floor plan. The plan provided shows a window that is located on the wall opposite the foot of the bed. Most of the furniture is on the lamp side of the bed. I had to decide on a camera angle that offered the best possible view and that included the window and the majority of the props.

I began with several small thumbnail sketches to work out the placement of the character in the room. I wanted to show Emma as the primary figure in the sketch. While drawing, I thought about what Emma would be thinking, her gesture, and facial expression as she lies on her bed. I drew several poses and angles while experimenting with her attitude and which direction she would be facing. I settled on Emma facing the headboard opposite the window because it emphasized her obliviousness to the impending danger. The point of view I chose gives the

audience a feeling of her vulnerability and innocence.

Emma is the dominant and most interesting figure in the composition. My goal was to use Emma's gesture and personality as a way to draw the audience in before other parts of the scene are noticeable.

After working out those details, I began to think about the shadowy figure at the window. I drew several different silhouette shapes, some human and some monster-like. I chose the monster shadow because it seemed to be the most interesting and I like monsters.

When I design a scene, I am always looking to create something interesting with multiple layers of activity that will entice the audience to follow in a particular path of action. For this scene, these are the three layers of sequence that I want the viewer to follow:

1. The girl is involved in her own world of texting and not aware of a shadowy figure at the window.

2. The shadowy monster is peering in the window behind the blinds and looking at the girl.

3. The cat is sitting on the beanbag chair, aware of the danger and looking up at the shadow, which is up to no good.

The cat was not originally part of the assignment, but I decided to include her because I think it adds more depth to the storytelling. Adding a light source from a glowing lamp will also create more mood and drama to the scene and influence the viewer to look first at the girl, then the window, and finally the cat.

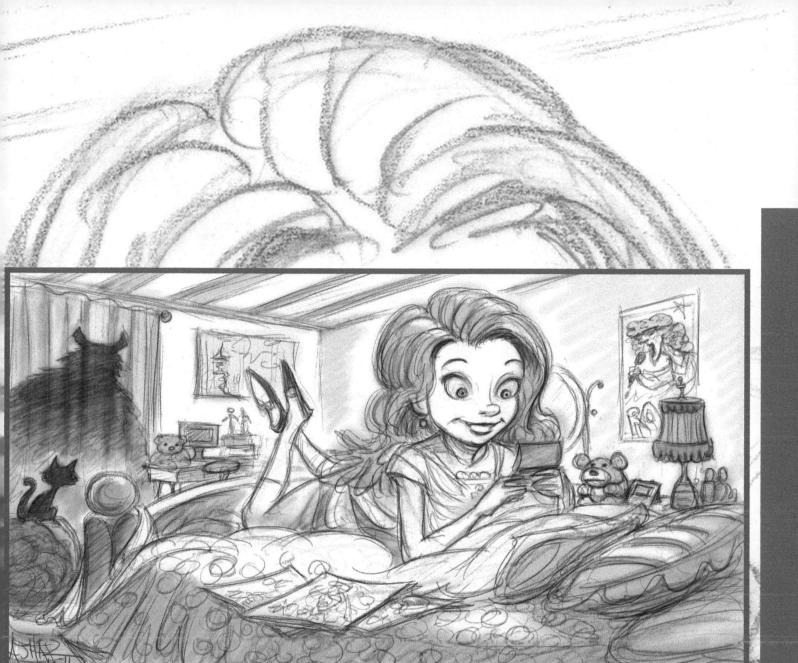

READER NOTE

Please see page 141 for the description of assignment #6.
All celebrity artists have created artwork with the same
guidelines given in that assignment so that we can see their
equally strong but varied approaches to the same challenge.

CHAPTER 6

LEADING THE EYE
Prioritizing by Design

LEADING THE EYE 6

Tom B.

Another important concept to keep in mind when staging your character in a composition is how your design "leads the eye" of your viewer. When we are designing an illustration, we usually have a story point, character point of view (which we'll get to in the next chapter), or a subject or object we want the audience to look at (or "read") first. Other parts of the composition may be secondarily important, but there is always a focal point to a scene – that one area of the design we want to visually lead the viewer's eye to. Staging a scene correctly is how you do this. Good design of the image is a large part of this staging.

VISUAL "FLOW" AND TONAL STUDIES

At Disney, one of the things the background painters would say was, "A good background should look incomplete without the character (level) in it." There was a bit of humility to that statement, but strictly from a design point of view, it meant that the background was *designed* with the character as the main focus. All the elements in the layout as well as the colors and lighting chosen *pointed* to the character – *literally*.

To help visualize this point, I asked my friend Megan Crisp if I could use some of her recent personal work. She created a project so she could experiment with a beautiful, stylized illustration style of her own. She has chosen to create visual development artwork for an imaginary animated version of the stage play *Wicked*. Megan designed development pieces to illustrate "moments" in the story, even adding back story to show what the main characters were like as kids.

After sketching thumbnails of what the layout might look like, Megan then creates simple tonal studies of the layouts. Tonal studies are a great tool for establishing – through only a handful of values of gray – where the dark areas and light areas of an illustration should be. This very simplified value study in gray then becomes your template for translating your illustration to color. The tones should help lead your eye to where you audience should look just as much as the design of the layout composition. As you can see from the following tonal study for the "Girl Reading" illustration, the layout is not finalized and still at an early stage of exploratory development. Even simplified like this, though, the tones and directional elements of the layouts really make the character stand out nicely.

In the final piece, you can see that Megan made many changes and additions that really strengthened the appeal and directional layout of the illustration. One change she made from the tonal study was to reverse the willow leaf colors. The inside color is now lighter and the outside is the darker tone. She made this change because she decided that her character was going to be a lighter shade to make your eye go to the character's eyes. The rule of thumb in all tonal studies is *dark* against *light* (or vice versa). In her tonal study, the character was dark, so she went light with the willow shape behind her; once the character changes, the background color needed to also.

If you look at the subset illustration, where I've gone over the layout with red arrows, you can see clearly how well she planned out her shapes in the composition to lead your eye toward the character – specifically, her face. Megan used the shapes of the tree, the clouds, and other background elements to create a visual flow within the layout that moves the audience's eyes right to the character. The colors and tones add more clarity to that sense of direction and flow.

In the next example from Megan's "Wicked" illustrations, this one called "Getting Closer," we see even in the rough tonal study a very clear, simple layout that makes the main characters the focal point. Again, Megan, uses the "dark against light" rule to make her characters really stand out. The sharpest contrast on your illustration should be between the background and the character(s) you are trying to put a spotlight on. In this case, the bridge is the darkest element in the tonal study, which works as well, but as you can see in the final, Megan has changed a few more things. The bridge is now more of a medium dark tone, which leaves the characters as the darker tone. To be sure, Megan has made the lightest, clearest area of the layout (the middle area of sky) the place where her characters are.

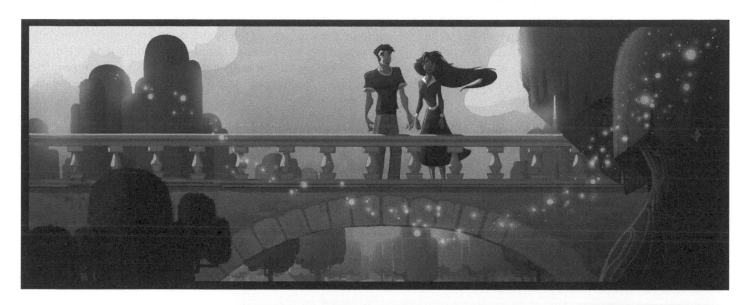

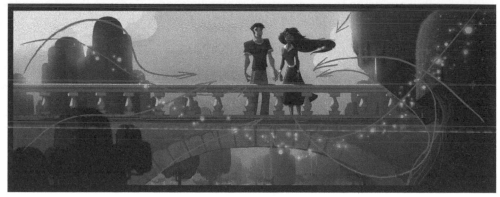

From a composition perspective, Megan made some strong additions to the layout. Some of the new bush and tree shapes help break up the symmetry nicely. All the elements aid in leading your eye directly toward the characters. As you can see in the figure above, the elements of the trees, bridge, and clouds all work together to highlight the young lovers. Great job, Megan!

SHAPE-BASED COMPOSITION

One of the most famous animation layout artists is Maurice Noble, a long-time head of the layout department at Warner Bros. Animation, who worked in the same unit as the great director Chuck Jones. Together, they worked on many of the timeless Bugs Bunny shorts and the perennial classic, the *How the Grinch Stole Christmas* TV special. Part of Noble's brilliance was his use of strong, simple shapes to define the spaces where the animation was to take place. A Maurice Noble animation layout looks like it's a film or theatre set. All the background elements frame the "stage" where the character was to act. Many times, Noble would literally place a color-based spotlight on the ground for the characters to be placed in. I have learned a lot about composition from Maurice Noble. My general approach to creating rough layouts is something I call *shape-based composition*. This way of thinking works hand-in-hand with the "visual flow" points I mentioned earlier regarding Megan Crisp's work.

To show an example of this way of thinking, I'll work on a short description that is like what an artist would get from a writer or editor on an illustration assignment for a book or magazine:

Bob and Johnny are walking far down the path in the scary forest, when suddenly a strong wind comes up behind them, slinging leaves all over and making them take off running.

First off, this is the kind of problematic description you would really get from an editor of a comic book, magazine, or children's book. In the description, many things are happening. First they are walking, then they are scared, and then they are running. Which one is it? You can't show all three. That's your job as an artist, to make that kind of decision on how best to show the description – at least *one* best way.

To start with, I am going to use a vertical rectangle shape. Because this is a made-up assignment, I could use any shape I want, but I like to decide on something and work within that challenge the best I can. I have thought about it, and I like the idea of illustrating the action as part of the description – being scared and running away from the wind that has whipped up – rather than the beat before when they are walking along. I decide that my goal will be to show a scary forest and have the audience's eye go to the two figures, scared and running away. I want the shapes of the trees – and maybe rocks, too – to point toward the figures in the distance. I may want to have dark clouds and the leaves blowing in the wind as visual elements, too. I feel like I have some clear ideas on what I want and I have not even started to sketch yet.

Here is how I approach the drawing using shape-based composition:

With a little bit of an idea of what I want (as stated previously), I start "finding" the illustration by drawing in the shapes I think will accomplish my goals. In this early phase, I am also thinking about the rule of thirds with regard to where I place shapes. I draw my rough, exploratory sketches in light-blue pencil at this point because it doesn't smear as much and I can drop out the blue sketch line later in the process. Even at this early stage, I am loosely thinking about the end color and lighting. I place my two figures at the end of the path, but in a clear area – this will make them pop out against the background and also gives me the ability to use the trees as framing elements around them. I have added some red flow lines for you to see the directional flow more clearly. My sketch may not make much sense to anyone else but me at this point, but hey, I am only five minutes into the illustration at this point!

I like where this sketch is going, so I start defining (in blue line still) some of the tree elements, where the moonlight source should be, and even some of the branches. Note that I am trying to skew the trees here and there and break up their placement so that I don't get straight, boring vertical lines. Variety is king here. My next step is to start refining things (though still in a rough sketch form) in terms of actual shapes in graphite pencil. I pick the two figures as the first thing to define, because their poses and clarity are most important. It will also help me move the trees around a bit when I tie them down later. I start adding in the fore-most element next – the leaves that seem to be chasing them off. They are the strongest directional element and, in my mind, the protagonist in my illustration – at least symbolically.

This phase continues the last phase of roughly defining the shapes in graphite. At this point, I am trying to emphasize the secondary directional elements – the trees and all their branches. As I mentioned before, I want the trees to have variety. I established that in the blue concept phase, but now I am adding the limbs and pushing those elements even more. Although most branches are pointing skyward, I am breaking some away to point downward, especially if they can point toward my key figures. In the sky, which I consider to be the third-level design element, I added the creepy clouds that seem to be following the characters. My general goal at this phase is to *add strength* to what is already working directionally. I consider where every rock, log, branch, or cloud that I draw should be to add to the flow of the scene.

And now I come to the finishing phase of the sketch concept. Remember that this is not a final illustration I am creating, but a tight concept drawing – something very similar to what I would show a client as one of many possibilities for a book illustration or film or TV visual development art. In this case, finishing the sketch means creating a tonal study – just using gray tones in Photoshop to establish the lights and dark areas of the illustration with an eye toward clarifying the elements. First, working in Photoshop, I use the Channels tool to select the blue level in my RGB scan of the artwork. I then go to Mode and select Grayscale. This step knocks out the blue and leaves me with just the black graphite linework. I have a much tighter sketch. I now add another level for my gray tones. As I mentioned in the beginning phase, I want the characters to stick out against the background. My first tonal decision is therefore to make the far background a light area so that my dark figures are clear against it. I am not a master of color, so I work simply at this stage. I tend to use three levels of gray – light, medium, and dark – with white and black being my darkest and lightest elements. Five tones is plenty to establish a simple gray tonal study that will make things more clear and give a client/art director a good idea of what the scene will look like when finished in color. Remember: the strongest contrasts work best: light against dark or dark against light. Light tones recede and dark tones come forward. I used that theory in this illustration.

I have added this illustration for you to see the elements I used to push the flow and subliminal directional lines in the final rough concept. Most of them were there even at the earliest phase, but now I have even more with every log, branch, leaf, and cloud I added to the composition. From start to finish, this took me about an hour and a half to two hours to create this shape-based compositional sketch. If this were for a client, I would most likely create two or three more sketches for the same scene, especially as the description was a hard one with many visual options.

DETERMINING PRIORITIES

The first thing I do when presented with an artistic challenge is to establish my *priorities*. If I had to make a list of what elements I want the viewer to see first, then second, third, and so on, what would it be? Establishing this list in my head before I sketch gives me a direction. Without a goal and priorities for an illustration, you have no idea whether your composition is successful. I would not know how to design the composition to lead the eye of the viewer without such a list. Ultimately, I would be drawing aimlessly.

To illustrate this point, I'll give myself a short story description (similar to what a book illustrator or comic book artist would get) to stage and layout:

> **A man, unconscious on his bedroom floor, with a bottle of poison next to him.**

I start asking myself questions: if I were viewing this scene, what would I think of first? What killed this man? Who is he? Where are we? Did someone do this to him? Why did this happen? (The last question is something we can't really show in one illustration, but we could hint at it.)

After thinking about those things, here are my priorities based on the previous description:

- **First priority: seeing that poison bottle (and being able to read the label clearly)**
- **Second priority: showing the body**
- **Third priority: establishing the bedroom setting**

My next step is to start making small, loose thumbnail sketches – drawing as many versions of this scene as I can think of and using the design principles already discussed. Basically, I'm moving the "camera" around the room and moving (staging) the elements in the room to where I need them to be. This time around, we want to have an even more careful eye to stage elements in a way that will lead the eye to the poison bottle.

Sketch #1:

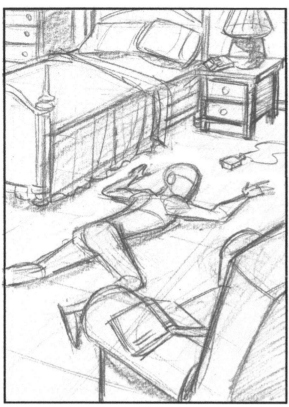

My first sketch is just okay. Everything is clearly staged, which is good. But the composition is top heavy, meaning that most of the detail of the drawing is in the top half of the drawing with very little happening on the bottom half. Most important is that the bottle is unclear. It could be a bottle of cold medicine, for all we know.

This sketch is dramatic. Now we can see that it is poison for sure, and that's great! I like the drama of seeing the dead guy's face, too. One problem that I see is that it's not clear where we are. We can't tell that it is a bedroom in this one.

Sketch #2:

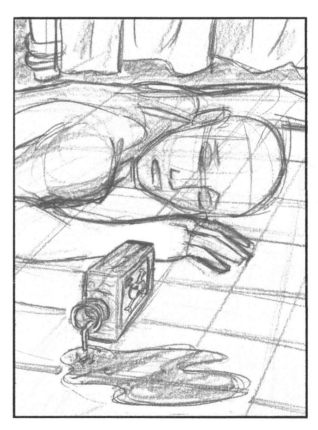

Sketch #3:

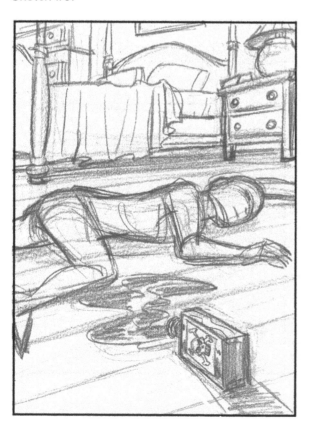

Much better! We now have interesting depth to the image and can clearly understand our story points: the poison, the guy, and the bedroom.

But could it be better?

Yes. Sketch #3 addresses the important story points, which is most important, but never stop there. This composition can be strengthened. There are a couple things that can be improved.

Sketch #3:

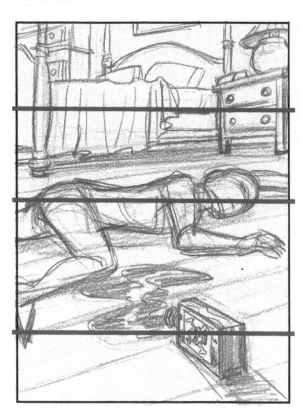

Sketch #3 breaks up into three different planes:

All of the planes are fairly evenly spaced.

That's one problem. The other is that the elements in the illustration lead the eye all over the room rather than to the poison: our main story point. Because we tend to look at the middle of an image first, this is usually a good place to put your focal point. (Note: dead center is not strong design, but just off center works well.) In sketch #3, the body is in the middle, so it becomes the focal point.

Two things we can try are using design elements in your composition to lead the eye in a stronger way and being more careful about how we break up the composition.

Let's do some more thumbnails to try and find some solutions to those problems. Sketch #4:

Sketch #4:

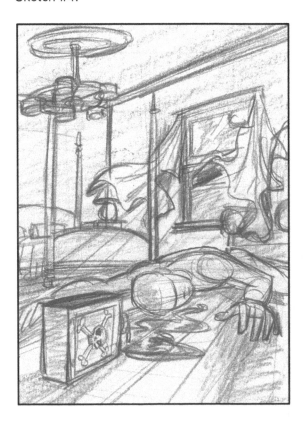

This sketch is stronger. I made it more of a worm's-eye view, putting the poison on the left with the body facing towards it. Making the bed a sleigh-style bed and putting a window across the room not only creates a little drama/movement in the room but also provides design elements that point toward the poison.

Sketch #5:

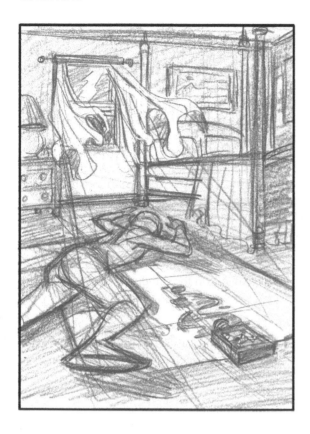

This version is even stronger! We are now looking down on the scene a bit, so the poison is a bit smaller, but many of the staging elements are directing our eye toward it – including the body's foot and the poisonous liquid coming out of the bottle.

Which one is your favorite? I could do many more, but I hope with these you get the point. Leading the viewer's eye and making artistic priorities are important parts of staging a composition.

COMPOSITION FOR A CLIENT

Recently I was asked to create concept designs for a computer-generated animation series being produced by The Christian Broadcasting Network (CBN) called *Superbook*. Each episode teaches kids a moral lesson through a Bible story. In the series, two kids and their robot friend travel back in time, via Superbook, to watch the Bible stories unfold firsthand. Artistically, each episode presents a complex challenge in creating iconic images that best sum up the story, characters, emotion, and the lesson that is being taught.

First, a little technical background: *Superbook* is a computer-generated animated series, but all the characters, environments, props, and storyboards are created with traditional drawings that are sent to the CG animation studio in China to be translated (modeled) into computer animation. Because I am working on the DVD cover artwork simultaneously with the episode's animation production, I use the traditionally drawn character designs and background visual development paintings to create my concepts. The Maya artists will then use my drawn concepts and recreate them in the computer using the CG-modeled characters and environments to produce the final artwork. This is why artists will always be needed in the CG production process, as it is easier for an artist to conceptualize through sketches and make changes quickly. Artists also provide a great tool of experimentation for the director, which saves money for the production. I call that job security!

I was asked to create concept designs for the *Superbook* episode "Roar!", which tells the story of Daniel and the lions' den. Normally, I get instructions or thoughts from the director and/or a producer. Since all of the key decision-makers were tied up with other episodes in production, I was asked to come up with multiple concepts and they would pick one (hopefully) that they liked best. My first step was to read the script. While I read it I made notes on what the key moments in the story were. The main points and characters in the story are:

King Darius wants everyone in his kingdom to worship him, not the God of Israel.

His royal advisors convince him to pass a law that says that anyone seen praying to God will be killed.

Daniel, a man of great faith, openly prays to God; the royal advisors see him and have him arrested.

The king respects Daniel but knows he must follow through with the punishment, so he has Daniel thrown into the lions' den (a pit), placing a huge rock over it for the night.

King Darius has a sleepless night and rushes to the pit first thing in the morning, ordering that the rock be pulled back.

All present see that Daniel is alive and has been miraculously saved as his God has calmed the lions.

King Darius is repentant and orders a new law for his kingdom: that all should worship the God of Daniel.

With these story beats in mind, I began thinking about the priorities of the story and what was important to show in my concepts. I put them into a mental order so that I could decide which things to focus on, and which elements or characters were less important. They are (in order):

Daniel, chained, paying for his faith

The lions, looking fierce

The uncertain King Darius

The royal advisors, looking conniving

The present-day kids viewing the scene and feeling helpless

I then gathered all the development artwork I would need to make my concepts as true to the series episode as possible. Below are the 2D character designs drawn by the talented Greg Guler for this episode.

SuperBook Daniel and the Lion's Den Episode

Daniel King Darius Royal Aides A Guard

There were some truly useful environmental designs created of the exterior of the Lion's Den Arena, drawn by J. Michael Spooner and painted by Lin Zheng, and the interior of the Lions' Den which was drawn by Phil Dimitriadis and painted by Lin Zheng. Both are beautiful as well as historically accurate.

E061 INT Lion's Den

E063 EXT Lion's Den Arena

With all the research done and the visual development artwork in hand, I was ready to begin. I wanted to create a variety of different ways to show the main scene: Daniel either about to be or in the lion's pit. That's the heart of the drama of the story, which is usually what you want portrayed on the cover.

"ROAR" VER 1

Because of my love of comic books and animation, I like to create a sense of movement in my illustrations whenever possible. I drew concept #1 because it shows a dramatic scene with some action. This concept plays up the danger of the situation and gives the "what's going to happen" feeling. It does not illustrate any of the moral messages though. And the king's remorse is not highlighted here, either.

I call concept #2 the "direct" concept. It shows a bound Daniel (obviously in trouble for something) and a furious king, literally pointing *into* the lion's pit! For a cover image, being as clear as possible is one of the most important things you can do, so for that reason, I liked the idea of this one. But the concept still shows only two characters and does not feel very epic.

"ROAR" VER 2

"ROAR" - VER 3

Concept #3 is all about trying to tell as much of the story in one picture as possible. I liked this one a lot because most of the characters and their roles in the story are depicted clearly. Although I think it hit the level of drama I wanted, it is a less exciting design. It is a very symmetrical design overall, which is okay in some situations – but I thought maybe something else could be even better.

"ROAR" - VER ④

"ROAR" VER ⑤

For concepts #4 and #5, I went for more of a cinematic, movie poster feel. The show's producer and I are big fans of artist Drew Struzan's movie poster designs for epic works like the Star Wars series and Indiana Jones films. I looked at his work for inspiration on these two concepts. His posters are collage style, with vignettes of film moments, close-ups of characters, explosions, full-figure images of the star characters in an action pose, and strong design. I like elements of both of these, but what I like most is that they show the emotions of the characters. The beam of light shinning down on Daniel is symbolic of his faith, which I also thought was important to include.

In the end, the producers picked concept #1, and I was happy with that decision. I look forward to art-directing the CG team toward creating the final color image.

ASSIGNMENT #6

Using a 6×11-inch (horizontal) shape as your template, create an interesting composition of a preteen little girl (see the "Emma" model) lying across her bed, casually texting. Unbeknownst to her, she is being watched by a shadowy figure outside her window. You may create multiple sketches to discover the best angle (or "shot") to illustrate this scene.

But I want you to use only these elements and this format to her room:

- Use the "Emma" character from page 44.
- A double-size bed, a nightstand with a lamp and alarm clock on it, a make-up table with a mirror attached, a free-standing dresser, a small desk, a bean bag, and a few accessories such as coat hooks with scarves and hats, posters, a bulletin board, books and magazines, a rug, and a computer.

Use the layout on the right for the room:

I did not give this assignment to student artists to create their version with my supplemental mentor notes. This assignment was what I gave to the professional artists whose works appear throughout this book. Look at how they tackled the assignment and how varied their points of view all use the same materials and descriptions. It fascinates me to see the diversity you can obtain when giving the same project to different artists. Some stayed close to my character design, but most did their version of the design. I love them all and would be hard pressed to pick a favorite! Thank you to Bobby Rubio, Jeremiah Alcorn, Terry Dodson, Brian Ajhar, Sean "Cheeks" Galloway, Stephen Silver, and Marcus Hamilton for your efforts!

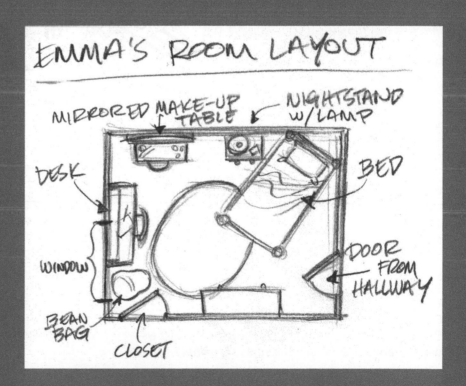

Try this assignment on your own. There are still a few thousand different ways to accomplish this goal successfully!

CELEBRITY ARTIST ASSIGNMENT
MARCUS HAMILTON
Comic Strip Artist

About Marcus

Marcus was born in Lexington, North Carolina, and graduated from Atlantic Christian College in Wilson, majoring in Commercial Art. In 1965, he and his wife Kaye moved to Charlotte, where he worked in the art department of WBTV.

In 1972, Marcus began a career as a freelance illustrator doing artwork for such publications as *Golf Digest* and *Saturday Evening Post*. But in 1993, his career and life took an abrupt turn when he responded to a TV interview in which Hank Ketcham, creator of Dennis the Menace, suggested that he would like to retire someday. Over a three-year period, Mr. Ketcham trained Marcus to take over drawing the daily (Monday through Saturday) cartoon panel, which is syndicated worldwide.

On May 28, 2005, Marcus was awarded the National Cartoonists Society's annual award for Best Newspaper Panel of 2004 in Scottsdale, Arizona.

You can see more of Marcus Hamilton's artwork at http://www.dennisthemenace.com/marcushamilton.html.

His Thoughts on the Assignment

First, I do a rough sketch of the room to define the placement of props in the scene (sketch #1). This step helped me to realize that the "camera" would need to be facing the direction of the window so that the shadowy figure would be visible. I felt that it would work better to have Emma in the foreground, so it is obvious what she's doing. To give the shadowy figure (in window) enough exposure, the angle would need to be low (sketch #2). Sketch #3 was to get all of the furniture and props in proper perspective and position.

The final piece is the placement of Emma, innocently enjoying texting her friend.

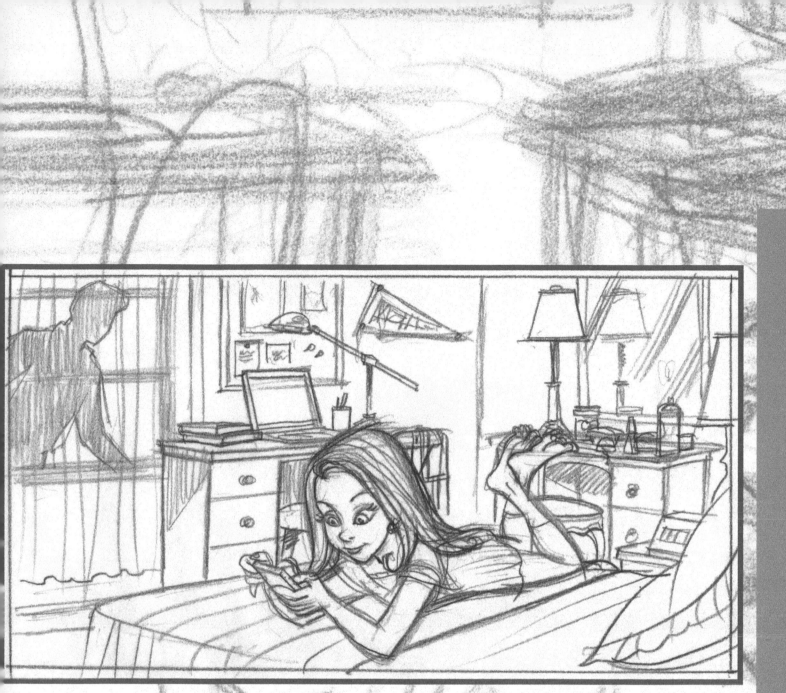

READER NOTE

Please see page 141 for the description of assignment #6.
All celebrity artists have created artwork with the same
guidelines given in that assignment so that we can see
their equally strong but varied approaches to the same
challenge.

CHAPTER 7

PUTTING IT IN ACTION

Creating a Character-Driven Illustration from Start to Finish

PUTTING IT IN ACTION

7

Now that we have gone through the elements of expression, posing, and staging for your composition, now comes the fun part: creating an illustration from start to finish. I had a recent request that makes for a good example to look at as a progression. A friend of mine who is a talented illustrator in China asked me if I would illustrate my version of the ancient Chinese story "Journey to the West," also known as "The Monkey King," for an art book he was compiling for an international audience. This story is as old as their land and is engrained in their culture. The more I researched the story, the more intimidating the notion was for me to illustrate an image inspired from it. Much like our own early American or European folk tales, the story is grim at times and has many elements that mean something within that culture but might not translate as well to others. Still, the heart of the story is about a character, Sun Wukong (the Monkey King), who must overcome huge obstacles and mighty foes to find his destiny. This is the core story of many myths, legends, and Disney films, so I felt a little more comfortable illustrating my piece of it.

STEP 1: RESEARCH, RESEARCH, RESEARCH

Whenever I start a new character design or illustration, I do as much research as I can on the subject matter. If I am designing a cartoon bear, I will go to the Internet and research pictures and anatomy of *real bears*. I will most likely look at some versions of cartoon bears also, but it's important to remember the aspects of what makes a bear *look right* before you caricature it. And this rule is true for this project. I went online and searched for information concerning the "Monkey King" (Sun Wukong) character and his story. I found many different versions of how people have drawn him in the past and some good information on his story, abilities, and personality. Sun Wukong is a mighty fighter with many magical powers. I'd already started thinking that my illustration would more than likely center around a fight scene of some kind.

REFERENCE

STEP 2: CHARACTER DESIGN

My second step was to start designing the Monkey King character. When I design characters, I concentrate on the shapes that make up their design. In the case of Sun Wukong, much of what I read about the character made him sound mischievous and cocky. I tried to include that spunky side to his character designs. My first character design was fine – but not what I was really interested in.

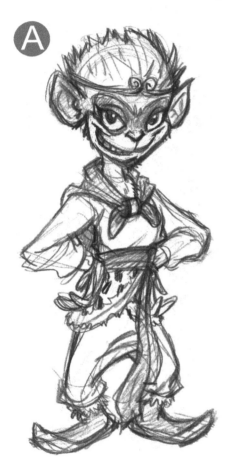

To get to know the character design a bit more, I did a few different facial expressions and poses. Because I am only doing the one illustration with this character, this step might seem like overkill – and it is, a bit – but doing this helps me solidify his shapes in my mind.

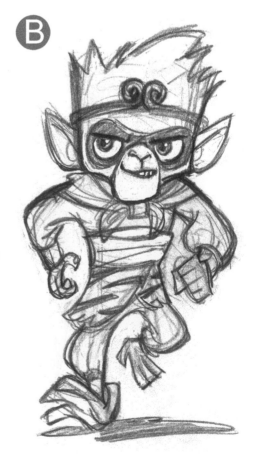

I wanted the finished illustration to have a stylized look, so I kept simplifying the design until I had one I liked. This design was the fun style I wanted to draw!

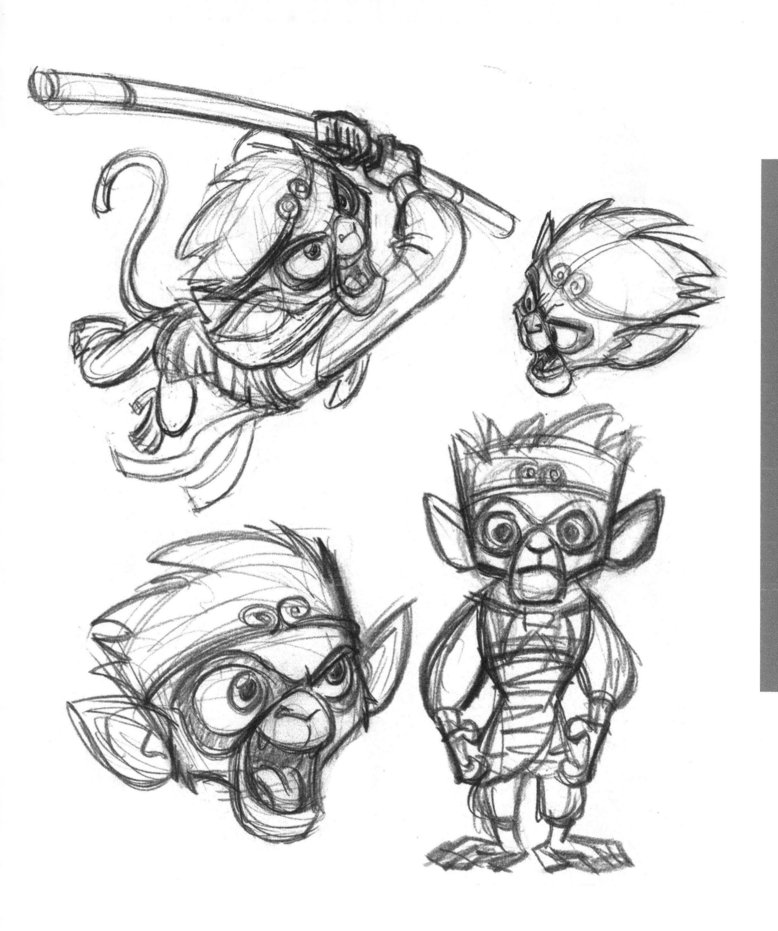

STEP 3: THUMBNAIL LAYOUTS

With Sun Wukong design in hand, it was time to work out what kind of picture I wanted to create with him. Because of my animation background, I like to put as much "movement" as I can into my illustrations. I knew I wanted to create a fight scene of some kind. I created at least nine different thumbnail sketches to find an idea I liked best – that's many more than I normally sketch out. Through my research, I discovered that the Monkey King fights a few different foes, including a fire dragon, a three-headed creature, and others. At the same time, I thought about different locations for this fight and decided that an aerial fight on mystic clouds (Sun's mode of transportation) somewhere in a mountain range similar to the Himalayas would be interesting. I began creating small thumbnail sketches to visualize different ideas. I knew I wanted the illustration to be a two-page "spread," so I made sure to plan out the composition so that no important elements (like heads, arms, or legs) were in the middle of the layout. Another goal I had was to create compositions that drew your eye through the illustration. Different elements in the illustration should visually lead your eye where you want the audience to look. In this case, I wanted the Monkey King to be the thing you looked at first. Second would be his foe, and third would be what they are fighting over – an ancient Buddhist temple. The "Journey to the West" story, like most ancient Chinese stories, has strong elements of the Chinese culture and religious beliefs interwoven into the story. My thought was that by adding the temple into the illustration, I am implying that the Monkey King is defending it.

I created thumbnail sketches A through F first. These six rough thumbnail layouts were all over the place, with different Sun Wukong poses, different angles, and multiple villains to singular dragons. In sketch C, I even had multiple dragons attacking him at once, with him ready to take them all on. I liked some of these concepts, but in the end, I liked the simplicity of Sun Wukong fighting an iconic Chinese-style fire dragon. The three I gravitated toward the most were A because of the midair fight (though I didn't like how Sun's body was going through the gutter in the middle) and B and F for their fun, action-based feel.

COMBO
OF
A B
& E

①

COMBO
OF
D & F

②

✓
YES!

③

I felt like I needed to dig a little deeper and narrow my focus once I knew what I wanted. I created three more thumbnail layouts, #1 through #3, in which I was trying to work out the Monkey King and the fire dragon's poses, as well as how the background would work with them. I played with the symbolism of *where* I placed the temple in all three. In thumbnail #1, it's below Sun Wukong, so it feels as though he is hovering over it in a protective pose. In #2, it's behind him, which strengthens the feel that he is defending it by placing himself between it and the evil dragon. In #3, it's between them; in the end, I chose this version because it felt the most like them both fighting over it because it's between them. It made Sun Wukong look a bit more on the offensive, also. I picked #3 for that reason, but also because I liked the feeling that this was a "moment" within the battle. The blast of fire has just left the dragon's mouth and Sun Wukong is evading it while winding up for a huge strike.

STEP 4: INKS

With a good idea of the layout, designs, and the character poses, I was ready to work on the final artwork. If I were coloring this illustration myself, I would probably do a larger, tight pencil sketch of the scene and start coloring that on the computer. But I had decided that I would rather not use my limited color and painting abilities on this piece, so I asked my good friend Chuck Vollmer if he would digitally paint it. Because he had agreed to it beforehand, I decided I wanted to give him the tightest linework I could, so that meant inking it. I also wanted Chuck to have full flexibility on the color and effects he wanted to achieve, so I made sure I created the final art as a layered Photoshop file. I began redrawing all the elements separately. I inked each of them with Pitt Brush markers on separate pieces of paper. I then scanned each element into the computer and put the final inked image together to match my thumbnail. Because each character, mountain, cloud, and temple were on separate levels,

this gave me the opportunity to subtly move the elements around to avoid tangents as much as possible. Many of my inked lines – in the background clouds and mountains, especially – were much too thick and distracting in this phase, but I knew it wouldn't matter in the final color phase. Chuck would drop the linework out completely in the background later in the process. On to *color*!

STEP 5: COLOR WIZARDRY

Color "wizardry" may sound a bit overblown, but Chuck Vollmer – like other incredibly talented digital painters – can make this part of the process look magical. I have known Chuck for 20 years. We worked together at Walt Disney Feature Animation in Florida for about 12 of those years. He was a traditional painter in the Background department and I was upstairs in the Animation department. Disney is very departmentalized, so we rarely had a production reason to interact, but I always enjoyed sneaking downstairs to see what Chuck was painting and watch him for a bit. I miss the smell of paint and the rainbow-colored splatter of paint that he would have all over the edges of his desk. Because painting an illustration is a book-length topic in and of itself, the following descriptions of Chuck's process are highly condensed. Needless to say, there are many, many more substeps within these few.

I had loose ideas of what colors I saw in my mind for this illustration, so our first step was to open up the digital inks file and discuss the color. The important color instructions I gave Chuck were some specific color reference (see the reference sheet at the beginning of this chapter) of Sun Wukong's costume, the fact that the dragon was a *fire* dragon and so therefore should have plenty of yellow orange and/or red in him, and the idea that it should be around sunset. One of Chuck's first points to discuss is where the light source was. Was the sun setting on the left or right? This, and the fact that the fire dragon itself would be radiating light, are important benchmarks to help Chuck decide how the illustration should be lit. We discussed how the light could be used to accent the characters and help them stand out. With all those thoughts swirling in his mind, Chuck started painting.

Most painters start with dark colors first and then work from there with lighter colors. Chuck also likes to start with the characters who are going to be the main focus. Establishing some of those decisions early helps you make the next color choices as you continue on through the painting. He decided to go with a darker red dragon to make him look evil. He also knew that he would be lightening him as he went, so starting with bold colors like this was a good idea. He also starts working in the clouds behind the dragon to see how the colors are working together.

Jumping ahead a bit, Chuck next established the Monkey King's colors based on the reference I gave him. He was almost fully rendered at this point. Chuck also added a nice sunset feel to the sky and established the dark mountains in the back. Chuck was unsure about the dragon's colors at this point, so he left him alone for a while. Before he even picked up his stylus, Chuck and I knew that the fire dragon would be the biggest challenge to the color process of this illustration. That premonition was coming true.

The next morning I came into work and saw this version of the fire dragon on his monitor! Chuck said he went home the night before and wrestled with his thoughts on what the dragon should look like. He had come up with this semiradical idea of using some greens within his body colors and switching the reds to oranges and yellows. He wanted to achieve the feeling that the dragon was burning from the inside. I loved it! He had also painted in the temple, the cloud the dragon was on, and the initial colors of the fireball. It was starting to come together now!

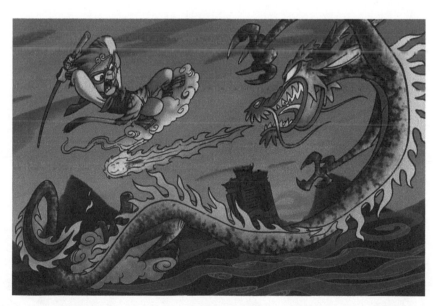

At this point on an illustration project, things slow down for Chuck. This point is also the fun part for Chuck: the detail work. The big decisions are made – the ones that keep him up at night – and now he can just *paint*. The biggest change at this point is that he turned off the black linework in the background clouds, the mountain, and the temple. This change softened the background and made the foreground figures stand out considerably.

On the next two-page spread, you can see the final illustration. Chuck added some glowing lighting effects to the fireball, but the biggest change is that he "colorized" all of the character's black linework. This effect really makes the characters come to life for me. The goal is for the characters to pop off the background, but also work within it – and now they do. I couldn't be happier with the painting on this illustration!

CELEBRITY
ARTIST ASSIGNMENT
JEREMIAH ALCORN
ILLUSTRATOR/CHARACTER DESIGNER

About Jeremiah

Jeremiah "Miah" Alcorn is a visual development artist, illustrator, and designer working in the illustration and animation fields for numerous clients in various positions globally. He lives in Alabaster, Alabama, with his wife, four children, two dogs, one cat, one frog, and four turtles. Miah is really tall and likes to wear flip flops – a lot. You can see more of his artwork online at http://www.alcornstudios.blogspot.com.

His Thoughts on the Assignment

With this particular scenario, I knew from the beginning that I didn't want to actually show the shadowy figure at the window itself unless I absolutely had to. I don't know . . . the addition of the unknown for Emma just seemed to make an already creepy situation that much more alarming. Not sure if that comes across or not, but that's what I was hoping to get in there. In considering different approaches, trying to get the threat actually in the room with Emma somehow seemed like an interesting goal too. If I showed the figure on the outside of the window looking in, there was still the barrier of the wall/window to add a certain layer of protection to the situation for our texter. By turning the camera toward the wall, I was hoping to add to the suspense of the scenario a bit by removing that visual barrier of the outside wall/window. Although we get some small hints of the window frame within the shadow, the shadow itself is still actually on a wall inside the protection of the house. Is it a little scarier this way? I don't know, but I wanted to at least give it a shot and see what was possible. Within the shot itself, I chose a lower camera angle to make Emma seem smaller and allow more room for the cast shadow to seem larger. The tilt of the window toward Emma was also done to make the shadow more overbearing and threatening.

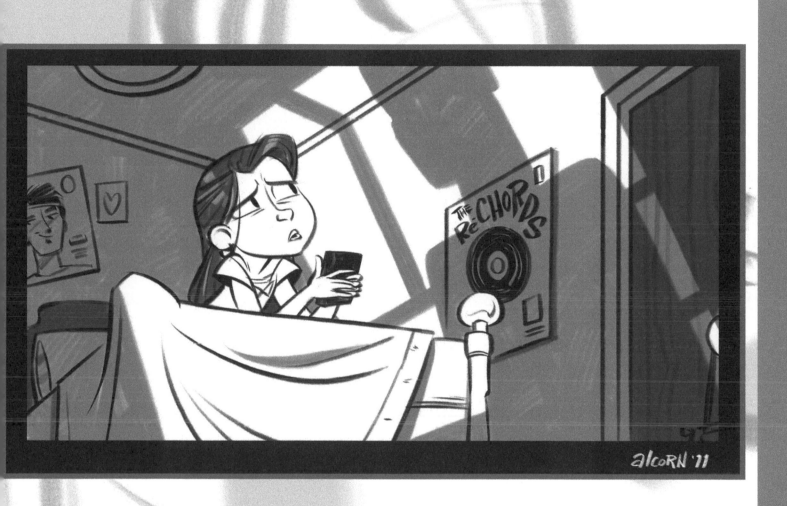

alcorn '11

READER NOTE

Please see page 141 for the description of assignment #6.
All celebrity artists have created artwork with the same
guidelines given in that assignment so that we can see their
equally strong but varied approaches to the same challenge.

INDEX

Page references followed by *f* indicate figure.